POSTCARD HISTORY SERIES

Chicago's 1933-34 World's Fair

A Century of Progress

IN VINTAGE POSTCARDS

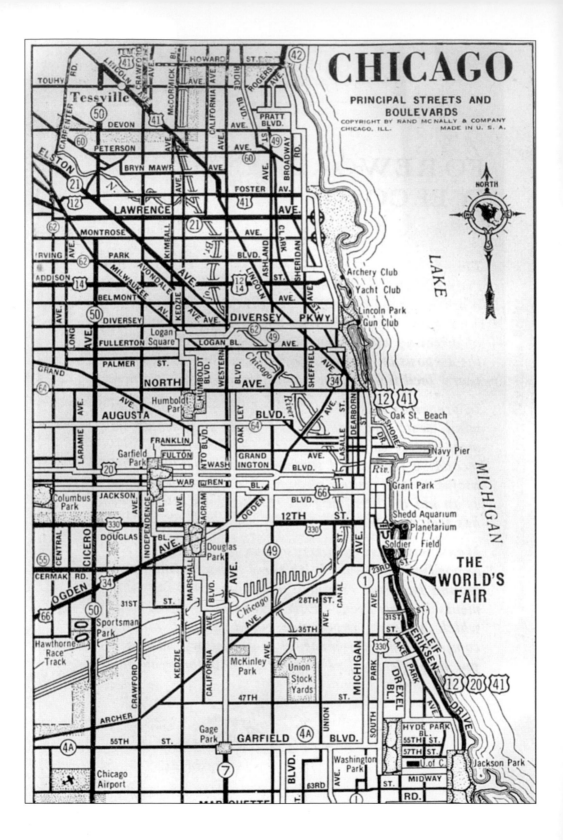

POSTCARD HISTORY SERIES

Chicago's 1933-34 World's Fair

A Century of Progress

IN VINTAGE POSTCARDS

Samantha Gleisten

ARCADIA

Published by Arcadia Publishing,
Charleston SC, Chicago IL, Portsmouth NH, San Francisco CA

Printed in Great Britain.

Library of Congress Catalog Card Number: 2002104608

For all general information contact Arcadia Publishing at:
Telephone 843-853-2070
Fax 843-853-0044
E-Mail sales@arcadiapublishing.com

For customer service and orders:
Toll-Free 1-888-313-2665

Visit us on the internet at http://www.arcadiapublishing.com

For Marie and Hank

CONTENTS

Acknowledgments

To my loving parents. Thank you for your continued support and gentle encouragement, despite my many failings. I love you both very much.

Special thanks to a group of people who have assisted me in so many ways: Valerie Shull, Sara Nodjoumi, Elizabeth Malo, Erin Crowley, Jonathan Hoenig, Justin Speer, Kathryn King, Eva Lindberg, Amber Zumstein, Anne Holub, Noah Simon, and John Byrnes.

And to the staff of Arcadia Publishing:

Keith Ulrich, for having the good sense to hire me in the first, I mean, second place.

John Pearson, for support and guidance along the way.

Mike Spiegel, for teaching me everything I know.

Holly Zemsta, for tireless promotion of others.

Jeff Ruetsche, for thinking this a good, or at least decent, idea to begin with.

Sarah Wassell, for weeding out the propaganda.

Jessica Smith, for good opinion and kindness.

Jane Elliot, for supporting this project and its author.

To the inventors and free minds of yesterday, today, and tomorrow, without whose hard work, insight, and innovation, the world would be a very different place.

And to the City of Chicago, which has adopted me as readily as I have adopted it.

IMAGE SOURCES:
American Colortype postcards: AC
Curt Teich and Company postcards: CT
Mini View Book postcards: MVB
Official Guide Book, World's Fair 1933: 33GB
Official Guide Book, World's Fair 1934: 34GB
Official Pictures, 1933: 33OP
Official Pictures, 1934: 34OP
Official View Book postcards: VB
Rand McNally, Century of Progress: RM
Stevens Hotel Postcard Book: SH

FOREWORD

by Mike Spiegel

Across the way from Soldier Field, just east of Lake Shore Drive, stands Balbo's Column. A gift from Benito Mussolini to the city of Chicago, it is the only structure remaining on its site from the Chicago World's Fair of 1933 and 1934. Meigs Field and McCormick Place now occupy the site where, almost seventy years ago, the city of Chicago presented the world an exhibition of global significance. Its significance was not so much architectural or economic as are most World Fairs; its significance lies in its psychological affect upon a country devastated by the Great Depression. To comprehend the significance of the Fair one must understand the times surrounding it. Conceived during a time of economic prosperity and exhibited at the nadir of the Great Depression, the Chicago World's Fair of 1933 and 1934 transcended two antipodean eras and succeeded unlike any celebration before it.

Chicago in the 1920s was a genre unto itself, full of antagonists and antiheroes, crisis and conflict, drama and discord. It was a genre that gave birth to the romance of the gangster, the bootlegger, a swinging time at a local speakeasy. It was a time when mobsters controlled law enforcement while corrupt politicians accepted bribes to look the other way, and figures like Al Capone became Byronic heroes whose actions became legendary. However, history is made up of black and white realities colored in by time and hyperbole. In reality, most Chicagoans during the 1920s did not own Tommy Guns. In fact, a vast majority of Chicagoans had nothing to do with the St. Valentine's Day Massacre. The truth is that, like most Americans during the post-World-War-I era, the citizenry of Chicago was caught in a battle between tradition and progress. World War I not only devastated Europe, it shattered the psyche of men and women around the world. Added to the psychological and physical horror of the Great War, in 1918 an international influenza epidemic killed over 20 million people worldwide. It is no wonder that many Americans—especially in the Midwest—felt a nostalgia for the innocent days before the war and plague. Fundamentalists saw the devastation as the wrath of God, a punishment for the sin they saw as prevalent. Evangelists and other fundamentalists grew in popularity and power as they led America in a crusade against immorality. This crusade resulted in the ratification of the 18th Amendment and the genesis of national Prohibition. Evident in the 1925 Scopes "Monkey" Trial, the fundamentalists saw scientific progress as an attack on the verity of the Bible and therefore, its practice was immoral. The quandary lay in the fact that this so-called "immoral"

practice of scientific progress was responsible for a large part of the ongoing economic expansion. Not only was this dilemma between the fundamentalists and modernists, it was a struggle within every individual during the 1920s—tradition or progress. It was amidst this socially and psychologically divided America that Rufus C. Dawes and Professor Michael Idvosky Pupin came up with the theme for Chicago's Centennial celebration: A Century of Progress.

A Century of Progress was organized as a not-for-profit corporation in January 1928 during a time of economic prosperity; however, just over a year and a half later, the fiscal foundations that allowed for such a prosperity fell apart. In January 1928, America was experiencing an economic boom. Technological advances such as the assembly line created more efficient labor, boosting manufacturing and industrial output. The Gross National Product rose 5 percent a year from 1920 to 1929, while per capita income grew 30 percent with virtually no inflation. The mighty roar of America during this decade was heard across the world until, suddenly, there was silence. On Monday, October 28, 1929, a $10 million bond issue was authorized by the Century of Progress Board of Trustees. The following day was "Black Tuesday"—the day the stock market crashed, plunging the country into the Great Depression. Half of the $10 million was guaranteed before Black Tuesday, but the organizers were faced with raising the other half while the country was in a depression. The organizers, informally known as the Corporation, could not burden the already impoverished city, state, and nation with a tax to pay the remaining $5 million, even though the previous exhibitions in Chicago, St. Louis, and San Francisco received an average of $9.3 million from federal and state funds. Not only did the Corporation have to raise $5 million in subscriptions, the Fair would have to succeed in order to repay the subscriptions after the Fair came to an end. Contractors and suppliers along with private citizens and corporations put their faith in their city by guaranteeing the rest of the money. The Fair opened at the lowest point of the Great Depression. Twenty percent of Illinois' population and 25 percent of the nation's labor force were out of work. Remarkably, by time the Fair closed in 1934, A Century of Progress was the first such Exposition to break even, let alone make a profit.

The success of the Chicago World's Fair of 1933 and 1934 is a tribute to the times, the organizers, and the human spirit. There were 47 million visitors from all over the world who came to A Century of Progress during 1933 and 1934. The total revenue of the event was $43.5 million. The Chicago World's Fair reflected an outpouring of optimism amid the depths of a global depression. People from all over the world were drawn to Chicago, for this exhibition offered hope. Most of the exhibits neglected the past and the present to focus on the future in order to celebrate scientific progress, providing men and women a much-needed escape in the promise of a better tomorrow. The organizers of the event understood the population's need for escape during such trying times. In persisting amid economic instability, the Corporation gambled on the unconquerable nature of the human spirit and its ability to persevere through hardships. The gamble paid off handsomely for the organizers, the city, the nation, and the future.

INTRODUCTION

When I undertook this project I had no idea how it would unfold. I discovered a collection of 1933-34 World's Fair memorabilia and was immediately drawn in. I found the aesthetic, presentation, and message of the Fair—A Century of Progress— compelling, straightforward, and absolutely worth celebrating.

The year was 1933, and the toast to world accomplishment, originally scheduled to last five months, continued for two years, welcomed over 47 million people, and made a profit—despite the global depression.

It was decided in 1927 that the 1933-34 World's Fair would be held in Chicago. The initial name for the Illinois not-for-profit-corporation established to organize and plan the event, "Chicago Second World's Fair Centennial Celebration," was changed on July 9, 1929 to "A Century of Progress." Although Chicago was host to the 1893 Columbian Exposition just 40 years earlier, much had changed in that time, both worldwide and at home. Besides, Chicago's 100 year anniversary, from a village settlement of 350 in 1833 to a thriving industrial, economic, and entertainment metropolis with over 3 million residents in 1933, was a perfect time for commemoration. The Fair's title, "A Century of Progress," was in honor of the city's history. And the city's history and epic growth was rooted in science and industry.

And so, "Chicago, therefore, asked the world to join her in celebrating a century of the growth of science and the dependence of industry on scientific research."(1933 Official Guide Book)

But the Fair did not avoid the unscientific. A stone's throw away from exhibits illustrating the groundbreaking effects of gas heating, assembly line processing, and food additives, barkers invited the curious to pay a few cents, enter shaded tents, and witness the unbelievable; a flea circus, a freak show, the Midget Village, and the list goes on. Imagine it, within the same stretch of lakefront, the progress and achievement of mankind was coupled with the excitement and thrills of "Ripley's Believe It or Not?," two-headed babies, and exhibits from around the world. What could be better? Of course, the Fair was not without its faults.

While industrial progress was rapidly being made, social and political problems persisted. The Great Depression was taking its toll on the nation, and as Chicagoans welcomed the influx of jobs brought by the Fair, the wealth was not distributed to all. While the Exposition had an official non-discrimination policy, few African Americans were employed by the Fair. And relics of

America's often imperfect past were evident in such exhibits as the "Old Plantation Show" on the Fair's midway, and the "Indian Village" located within the U.S. Army Base Camp.

And while visitors to the Fair reveled in the "Black Forest" and "German Village" exhibits, the international scene in Europe was not as celebratory. Only a few months before the Fair's May 27, 1933 opening, Adolph Hitler was named chancellor of Germany. That same year, concentration camps were set up.

With every moment the world was shifting and the story left for the future was changed. As industry moved to meet scientific advancements, fueled by humanity's thirst for newfound comforts, tools, and possibilities, the world's landscape was forever altered. But just as human innovation and creativity provided for more luxuries and conveniences, it also made destruction and devastation far easier. Science and industry would alter our lives completely. From the dawn of telecommunications to the A-bomb, the power to create and destroy had been harnessed.

The 1933-34 World's Fair is one chapter in a most influential time. It offered an opportunity to reflect and realize how quickly the world was changing economically, socially, and commercially, while honoring that which made it all possible—the human spirit.

This book does not intend to tell the whole story of the Fair. Instead, it offers a brief glimpse into a fascinating world. A world at a great turning point, marked by what it had accomplished and faced with what it would choose.

Opposite: **THE AVENUE OF FLAGS.** From the main gates to the Hall of Science, Fair-goers walked in grandeur down the Avenue of Flags. As noted on the back of this postcard, this was "a fitting promenade leading to the wonders of this great exhibit." (AC)

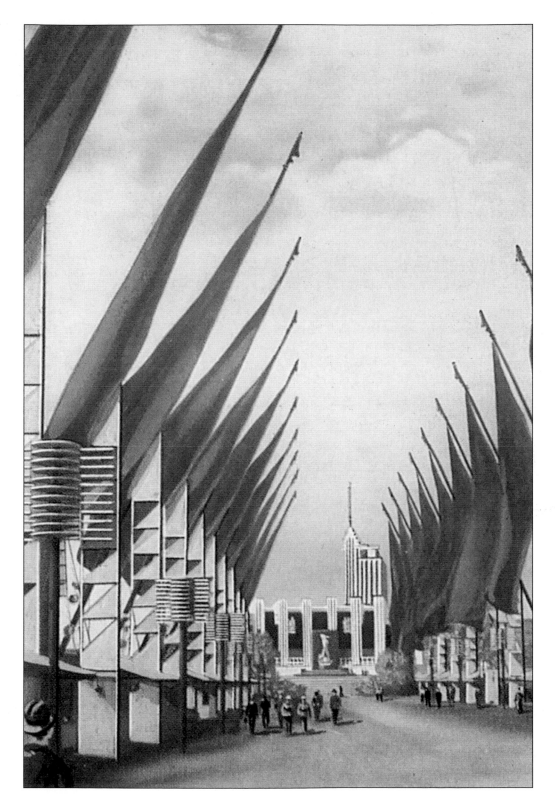

A Look at the Times

1930
Over 1,300 American banks fail and unemployment exceeds 4 million.

1931
*Unemployed Americans march on Washington to demand
a national employment program and minimum wage.
The rise of Japanese militarism is marked with the occupation of Manchuria.
Chicago mobster Al Capone is sentenced to 11 years in prison and a fine of $50,000 for tax evasion.
"The Star-Spangled Banner" becomes the American national anthem by order of Congress.*

1932
*Franklin Delano Roosevelt is elected president for the first of four terms
under the promise of a "New Deal" for America.
Wall Street's Dow Jones Industrial average hits 41.22, a Depression-era low.
The Great Depression's affects continue:
1,161 banks fail, almost 20,000 businesses go bankrupt, and 21,000 people commit suicide.
Gandhi protests British treatment of India's untouchable caste
through a civil disobedience "fast unto death." He won concessions after 6 days.
Charles Lindbergh's son is kidnapped and killed.*

1933
*Adolph Hitler becomes chancellor of Germany. By year's end he has proclaimed the Third Reich,
eliminated all political parties other than National Socialism, established his dictatorship,
and opened the first concentration camp in Dachau.
Chicago Mayor Anton Cermak is assassinated in Miami by a bullet intended for FDR.
The government implements New Deal legislation.
Prohibition ends. As a result, the sale of caffeinated beverages declines.
Food processing and additive discoveries allow for the creation of Spam. TV dinners soon follow.
Frequency modulations allow for radio reception with no static.
FDR begins recording "fireside chats" for weekly broadcasting.*

1934
*The Dust Bowl devastates farmers in Kansas, Texas, Colorado, and Oklahoma
by blowing an estimated 300 million tons of topsoil into the Atlantic Ocean.
The Federal Communications Commission (FCC) is created to oversee radio, telephone,
and telegraph communication in the U.S.
Clyde Barrow and Bonnie Parker (Bonnie and Clyde) are killed by police in Louisiana.
John Dillinger, Public Enemy Number One, is killed in a gun battle with the FBI
in front of Chicago's Biograph Theater.*

One

CHICAGO

A CITY ON DISPLAY

Picture it. It's an early fall day in Chicago, the leaves on the trees in Grant Park are beginning to change color, but the sun is still warm, and the birds still plenty. The impressive Chicago skyline is marked, not by the Sears Tower or the John Hancock Building, but by the Chicago Board of Trade, the Wrigley Building, and the Tribune Tower.

You arrive in the city by early morning train, traveling on one of the 1,500 passenger trains that come to Chicago daily. You have five dollars in your pocket and a very full agenda, not bad for Depression-era 1933. Once downtown, you hop on an elevated train, at a cost of 10 cents, and get off at Roosevelt Road Station, just 2,000 feet away from the North Entrance of the World's Fair. The Shedd Aquarium stands to your left, the Field Museum, at right, and before you, looking south, A Century of Progress awaits.

You purchase a ticket for 50 cents and gain access to a world of wonders. Stretched out from where you stand, all the way to Thirty-Ninth Street on the South Side, are 424 acres of scientific discovery, industrial advancement, thrilling rides, freak shows, peep shows, and world exhibits. It is going to be a full day. You buy an *Official Guide Book to the Fair* for 25 cents and start walking down the grand Avenue of Flags. The exploration has begun.

After hours of mind-stretching exhibits that span the gamut from the creation of light to the make-up of the city dump, you grab a bite to eat and a beer at one of the many restaurants on the fairgrounds. After all, Prohibition is over. Your lunch costs about 15 cents, and after you digest, you treat yourself to admission at the freak show for a quarter.

The day has sped by, the sun begins to set, and the Fair illuminates half of Chicago with color as the lights of the Exposition are turned on. The sky is drenched in brilliant reds, greens, blues, and golds, and revelers pause to take note. You continue to explore and then, hours later, exhausted by the day's events, you take a room at one of Chicago's many hotels for two or three dollars.

You will return to the Fair tomorrow, you think, wishing you could stay for a week. The scope of the grounds, the genius of the exhibits, and the optimism made possible by progressive forward thinking has affected your judgement and view of the world—a world that yesterday you looked at with pessimism and a furrowed brow, today you see with possibilities of tomorrow from a framework laid by a century of progress.

A great city is that which has the greatest men and women.

Walt Whitman

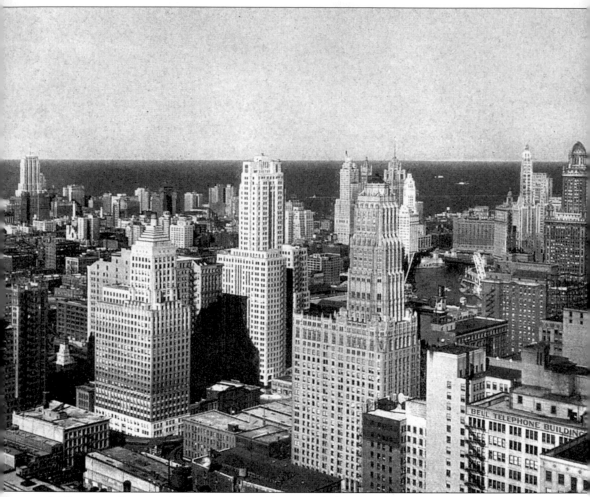

A VIEW OF CHICAGO'S DOWNTOWN. Chicago's skyline has changed drastically over the years, but it has always been on the forefront of architectural achievement in the U.S. This picture, taken just 60 years after the Great Fire of 1871, illustrates how quickly Chicago rebuilt and rose from the fire's ash. (RM)

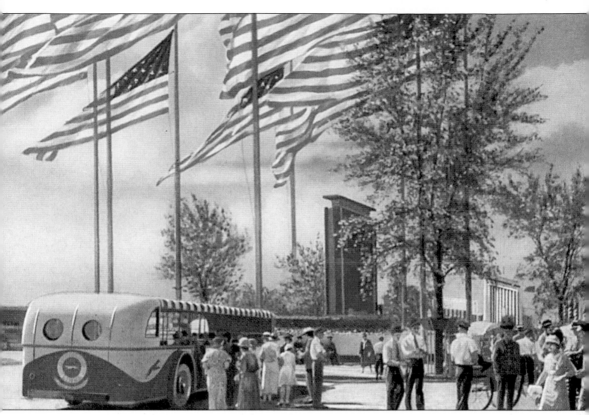

THE TWELFTH STREET ENTRANCE. "A Century of Progress was conceived and created to meet your tastes, however varied they may be. On the one hand, science beckons to serious interest, and, on the other, fun and carnival crook inviting fingers. Things of inner spirits offer opportunity for quiet contemplation, and sports and recreation sound their constant tocsins. Industry in numberless phases depicts its story or progress and of power, and art and music hold sway in supreme expression. The aged, the young, the student, the eager for gaiety, all can seek their separate ways, and find fulfillment of their needs. Even the children have a magic island of their own, a place of wonders."—From the *1933 Official Guide Book of the Fair*. (Photo—AC)

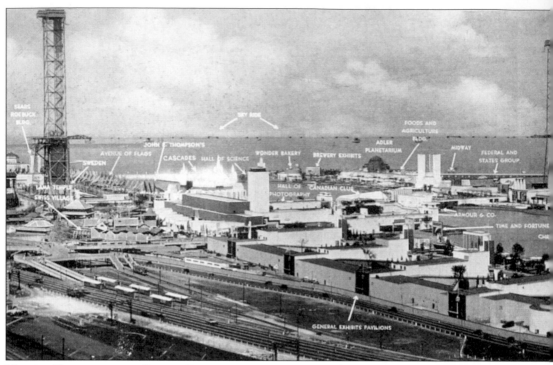

NORTH ENTRANCE TO SOUTH END OF THE LAGOON. Built on 424 acres of lakeside, much of which was actually created land drudged from the bottom of Lake Michigan, the 1933 World's Fair was originally scheduled to last a mere five months, from May 27th to November 1st. The

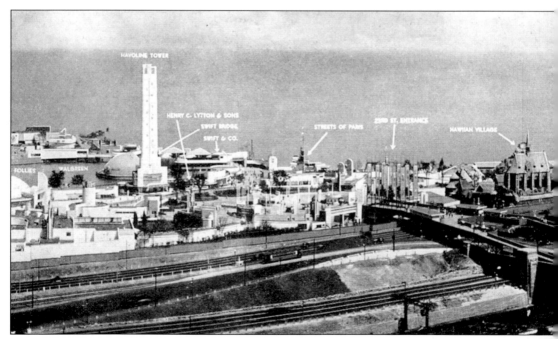

TWENTY-THIRD STREET TO SOUTH ENTRANCE. (34OP)

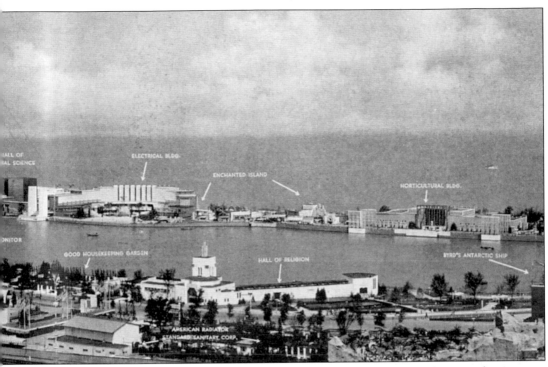

Fair's incredible success however, allowed the Fair to open again in 1934. These aerial panoramas help to illustrate the Fair's expansive layout. (34OP)

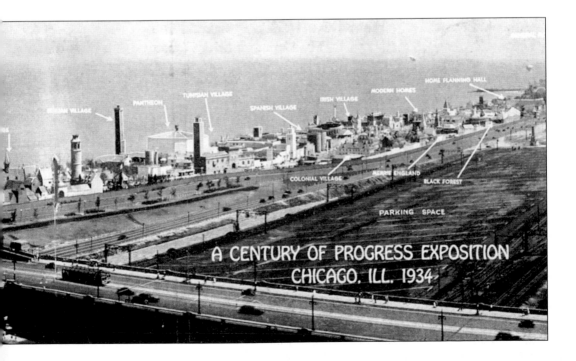

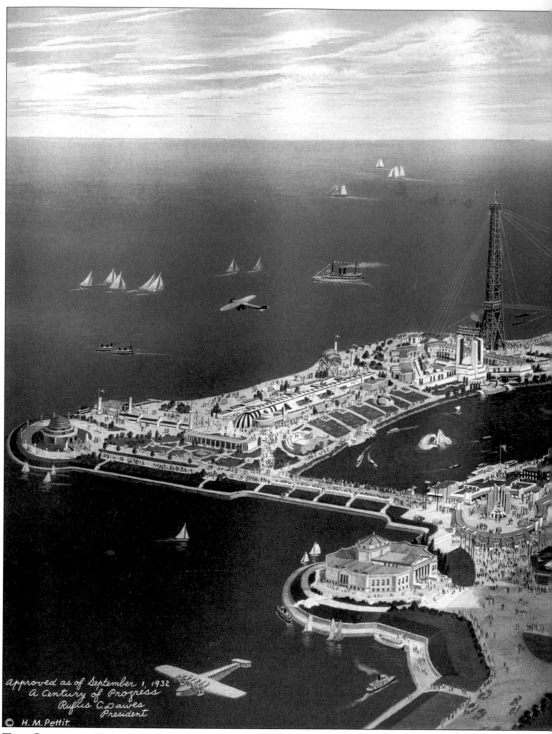

approved as of September 1, 1932
A Century of Progress
Rufus C. Dawes
President

© H. M. Pettit.

THE COMPLETE FAIRGROUNDS. This map, "approved as of September 1, 1932, A Century of Progress, Rufus C. Dawes, President," was made by H.M. Petit of Evanston, Illinois, and provides a beautiful illustration of the Fair and the surrounding Chicago landmarks that were sure

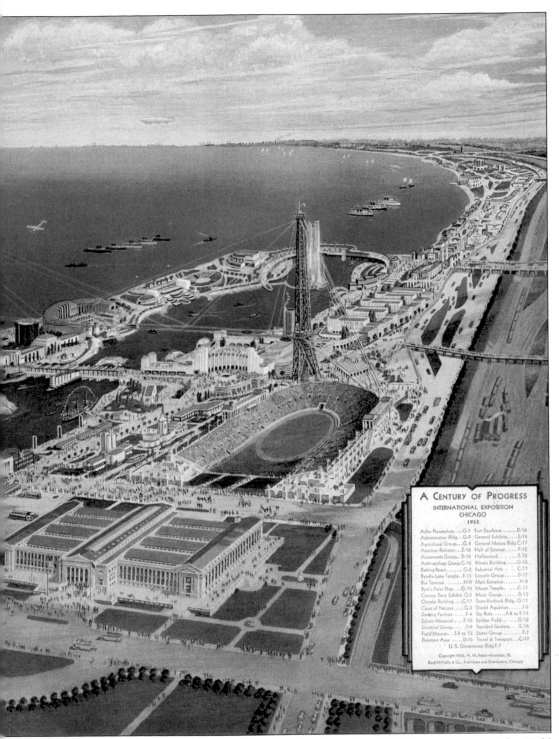

A CENTURY OF PROGRESS
INTERNATIONAL EXPOSITION
CHICAGO
1933

Adler Planetarium....G-1	Fort Dearborn.......D-16
Administration Bldg...G-9	General Exhibits.....E-14
Agricultural Group....G-4	General Motors Bldg..C-17
American Radiator...E-16	Hall of Science......F-12
Amusements Group..D-16	Hollywood.......E-18
Anthropology Group.G-16	Illinois Building......G-12
Bathing Beach........G-2	Industrial Arts....C-17
Bendix Lama Temple..F-15	Lincoln Group......D-17
Bus Terminal..........H-9	Main Entrance......H-8
Byrd's Polar Ship....G-10	Mayan Temple......C-17
Century Dairy Exhibit.G-5	Music Group.......D-13
Chrysler Building.....C-17	Sears-Roebuck Bldg..G-11
Court of Nations.....G-3	Shedd Aquarium......I-6
Dwelling Pavilion......F-4	Sky Ride......F-8 to F-13
Edison Memorial.....F-10	Soldier Field......G-12
Electrical Group.......I-9	Standard Sanitary....E-16
Field Museum...I-9 to 13	States Group......F-7
Firestone AreaD-16	Travel & Transport...C-17
U. S. Government Bldg.F-7	

Copyright 1932, H. M. Pettit—Evanston, Ill.
Rand McNally & Co., Publishers and Distributors, Chicago

to add to any Fair-goer's visit. By noting the location of such Chicago treasures as the Field Museum, Adler Planetarium, Shedd Aquarium, and Soldier's Field, the grand scale of the Fair becomes evident. (RM)

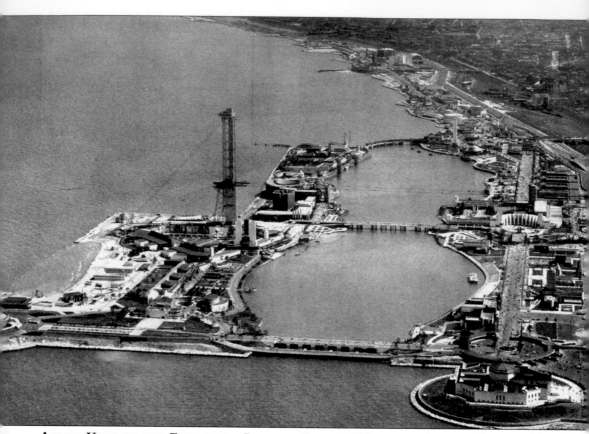

AERIAL VIEW OF THE EXPOSITION LOOKING SOUTH. Chicago was chosen as the site of the 1933 World's Fair for a great many reasons. Only 100 years prior to the 1933 Exposition, on August 12, 1833, Chicago was incorporated as a village with a population of 350. The name "Chicago" was derived from the Native Americans who inhabited the area and it is believed to mean "strong" or "great." As Dr. William Barry, the first secretary for the Chicago Historical Society, wrote, "Whatever may have been the etymological meaning of the word Chicago in its practical use, it probably denoted strong or great. The Indians applied this term to the Mississippi River, to thunder, or to the voice of the great Manitou." Certainly Chicago's history has proven this a fitting name. (33OP)

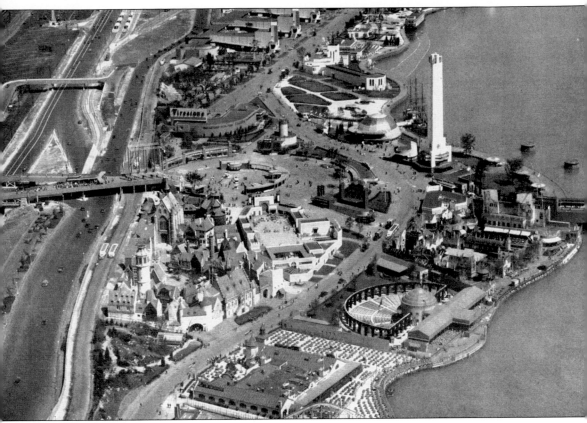

THE HEART OF THE EXPOSITION. This picture details the varied events surrounding the Twenty-Third Street Entrance, which was located just south of the South Lagoon.

Aside from being a splendid way to celebrate a centennial, Chicago was perhaps one of the few U.S. cities capable of hosting an event of this scale and industrial focus, particularly during the Great Depression.

A century after its incorporation, Chicago boasted a population of 3,376,438, according to the 1930 census, and was the second largest city in America. In 1933, almost a quarter of a million people worked in downtown's Loop. Chicago was fast positioning itself to become the great aviation hub it is today. And, as Carl Sandburg noted, the "City of the Big Shoulders" was America's railroad center, the "Player with Railroad's and the Nation's Freight Handler," with 33 trunk lines terminating in Chicago and an average of one train entering the city every 58 seconds. (33OP)

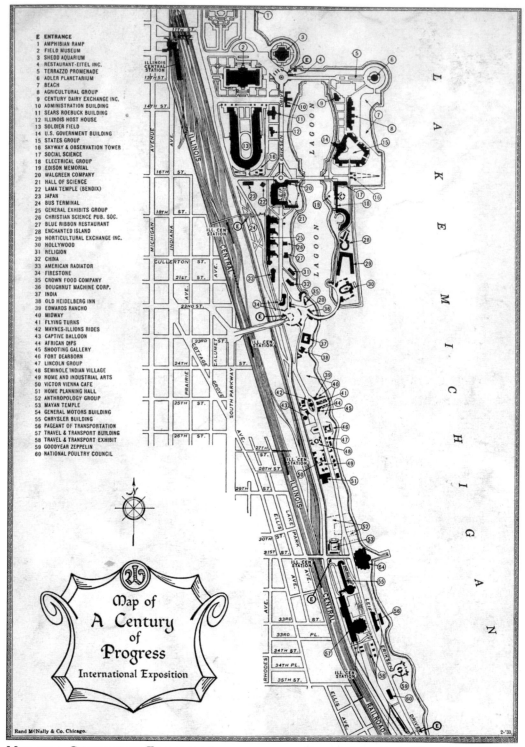

E ENTRANCE
1 AMPHIBIAN RAMP
2 FIELD MUSEUM
3 SHEDD AQUARIUM
4 RESTAURANT-EITEL INC.
5 TERRAZZO PROMENADE
6 ADLER PLANETARIUM
7 BEACH
8 AGRICULTURAL GROUP
9 CENTURY DAIRY EXCHANGE INC.
10 ADMINISTRATION BUILDING
11 SEARS ROEBUCK BUILDING
12 ILLINOIS HOST HOUSE
13 SOLDIER FIELD
14 U.S. GOVERNMENT BUILDING
15 STATES GROUP
16 SKYWAY & OBSERVATION TOWER
17 SOCIAL SCIENCE
18 ELECTRICAL GROUP
19 EDISON MEMORIAL
20 WALGREEN COMPANY
21 HALL OF SCIENCE
22 LAMA TEMPLE (BENDIX)
23 JAPAN
24 BUS TERMINAL
25 GENERAL EXHIBITS GROUP
26 CHRISTIAN SCIENCE PUB. SOC.
27 BLUE RIBBON RESTAURANT
28 ENCHANTED ISLAND
29 HORTICULTURAL EXCHANGE INC.
30 HOLLYWOOD
31 RELIGION
32 CHINA
33 AMERICAN RADIATOR
34 FIRESTONE
35 CROWN FOOD COMPANY
36 DOUGHNUT MACHINE CORP.
37 INDIA
38 OLD HEIDELBERG INN
39 EDWARDS RANCHO
40 MIDWAY
41 FLYING TURNS
42 MAYNES-ILLIONS RIDES
43 CAPTIVE BALLOON
44 AFRICAN DIPS
45 SHOOTING GALLERY
46 FORT DEARBORN
47 LINCOLN GROUP
48 SEMINOLE INDIAN VILLAGE
49 HOME AND INDUSTRIAL ARTS
50 VICTOR VIENNA CAFE
51 HOME PLANNING HALL
52 ANTHROPOLOGY GROUP
53 MAYAN TEMPLE
54 GENERAL MOTORS BUILDING
55 CHRYSLER BUILDING
56 PAGEANT OF TRANSPORTATION
57 TRAVEL & TRANSPORT BUILDING
58 TRAVEL & TRANSPORT EXHIBIT
59 GOODYEAR ZEPPELIN
60 NATIONAL POULTRY COUNCIL

Map of
A Century
of
Progress
International Exposition

Rand McNally & Co. Chicago.

MAP OF A CENTURY OF PROGRESS INTERNATIONAL EXPOSITION. From Eleventh to Thirty-Ninth Streets, the Exposition was filled with wonders, thrills, and lessons. (RM)

1933 Official Guide Book. The foreword to this guide states: "This is the official guide-book of A Century of Progress, Chicago's 1933 World's Fair. It contains the latest and most accurate information available on what has been accomplished and what is planned for this Exposition of the greatest era of the world's scientific and industrial history." (33GB)

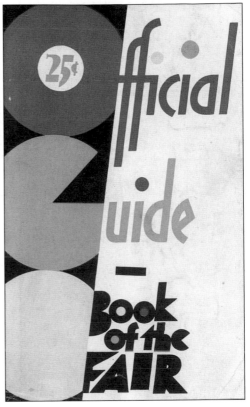

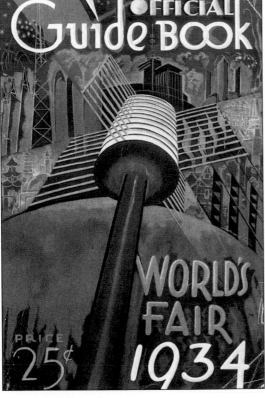

1934 Official Guide Book. After the initial success of the Fair in 1933, the Exposition was improved upon and held over for an additional run. This guide begins: "Many important additions have been made to the Exposition this year. With these the scientific background has been retained, with numerous improvements in operation. Every possible improvement which a year's experience could suggest for the comfort and enjoyment of our visitors has been put into effect. The Exposition is before you and we bid you welcome." (34GB)

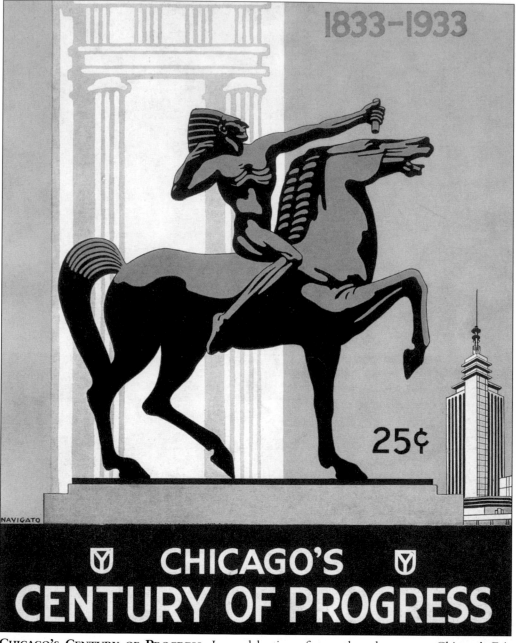

CHICAGO'S CENTURY OF PROGRESS. In a celebration of strength and greatness, Chicago's Fair honored the achievements made by a century of advancements in science and industry. Just 62 years after the Great Fire of 1871 Chicago had rebuilt and risen. And despite the height of the Great Depression, the 1933-34 World's Fair was a noted success. The human spirit can't be checked for long, if checked at all. "These are minds that are no more dismayed by a pause for readjustments than is the motorist who may halt beside the road to adjust his engine's carburetor. He does not believe his car irreparably ruined because of a minor flaw. He readjusts and goes on. And thus do the forces of progress sweep on. They are the forces of science, linked with the forces of industry."—From the *1933 Official Guide Book*. (Photo—RM)

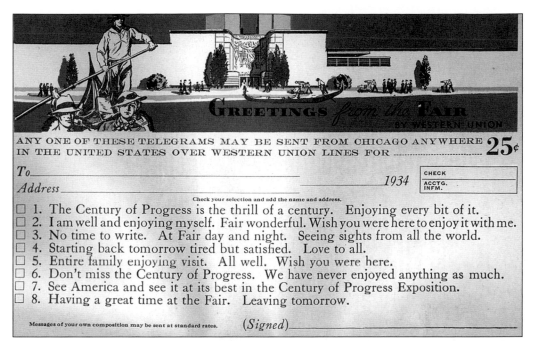

GREETINGS FROM THE FAIR BY WESTERN UNION

ANY ONE OF THESE TELEGRAMS MAY BE SENT FROM CHICAGO ANYWHERE 25¢
IN THE UNITED STATES OVER WESTERN UNION LINES FOR

To_____

Address_____ 1934

CHECK
ACCTG. INFM.

Check your selection and add the name and address.

☐ 1. The Century of Progress is the thrill of a century. Enjoying every bit of it.
☐ 2. I am well and enjoying myself. Fair wonderful. Wish you were here to enjoy it with me.
☐ 3. No time to write. At Fair day and night. Seeing sights from all the world.
☐ 4. Starting back tomorrow tired but satisfied. Love to all.
☐ 5. Entire family enjoying visit. All well. Wish you were here.
☐ 6. Don't miss the Century of Progress. We have never enjoyed anything as much.
☐ 7. See America and see it at its best in the Century of Progress Exposition.
☐ 8. Having a great time at the Fair. Leaving tomorrow.

Messages of your own composition may be sent at standard rates. (*Signed*)_____

GREETINGS FROM THE FAIR. For 25¢ Fair-goers could send a telegram to loved ones anywhere in the country, so long as their message was one of the eight listed above. Appropriately pictured on the telegram is the Exposition's Western Union Hall, which in 1933 was known as the Radio and Communications Building. (34GB)

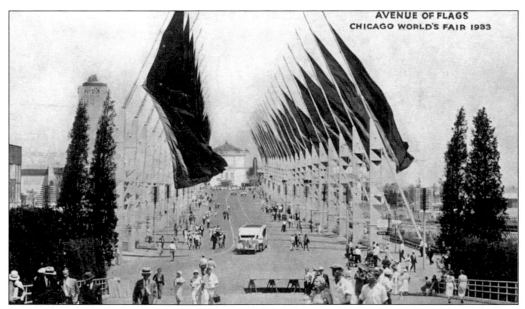

AVENUE OF FLAGS
CHICAGO WORLD'S FAIR 1933

THE AVENUE OF FLAGS. This is perhaps one of the most famous and splendid views of the Fair. The message on this postcard, sent from Ethel and Sally in Chicago to Alice in Richmond, Indiana, says a great deal about the experience at the Fair. "Having one glorious time and will tell you all about it later. We are now on the 20th story of a building waiting to be conducted on a tour of a broadcasting station. Home Wednesday eve." (The Process Photo Studio)

TWENTY-THIRD STREET ENTRANCE. Once visitors crossed the bridge over the Illinois Central Railroad at Twenty-Third Street and climbed the steps to the Exposition's center, a world awaited them. Just beyond this entrance stood such marvels as the Havoline Thermometer, Infant Incubator, Walgreen Building, and Neptune's Follies. (33OP)

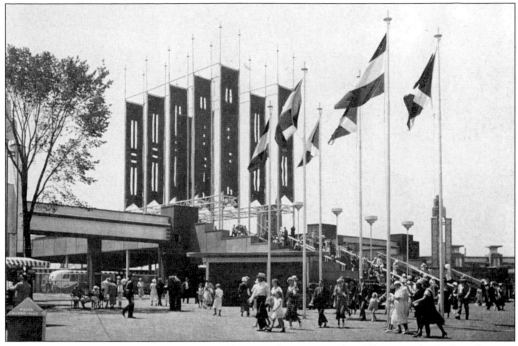

TWENTY-THIRD STREET ENTRANCE. The Fair drew over 48 million people during the two years it was held. While many of the visitors were repeat customers from the Chicago area, improved highway systems and excellent rail travel options made it possible for people to come from much farther distances. Fair officials estimated that about two-thirds of the attendees were from outside Chicago. (34OP)

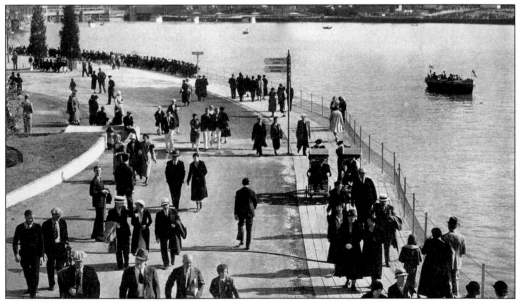

THE BOARDWALK ON NORTHERLY ISLAND. Leisurely strolling down the boardwalk in the most fashionable of attire, Fair-goers enjoyed the natural splendor of Chicago's lakeside Exposition as well as the wonders made possible by progress and industry. (33OP)

THE AVENUE OF THE FLAGS. This watercolor postcard gives an artist's rendering of the magnificence of this grand entry hall. Part of a view book of watercolor postcards, the accompanying note to the buyer by Allen D. Albert of the Architectural Commission reads, "Some of the more brilliant and some of the more poetic moods of A Century of Progress are presented in the cards in this folder. Americans who have visited the Exposition find in them a renewal of the exhilaration and sense of experience which marked their tour of the grounds. Those who have not yet come to the Fair gain through the cards an understanding of a scene which it is difficult to overdraw or over-color." (VB)

INTRA-MURAL BUS. In a feat of transportation advancement, the Exposition utilized a fleet of semi-trailer type open busses and accommodated 15,000 to 20,000 passengers per hour. (CT)

Happiness hates the timid! So does science!

Eugene O'Neill

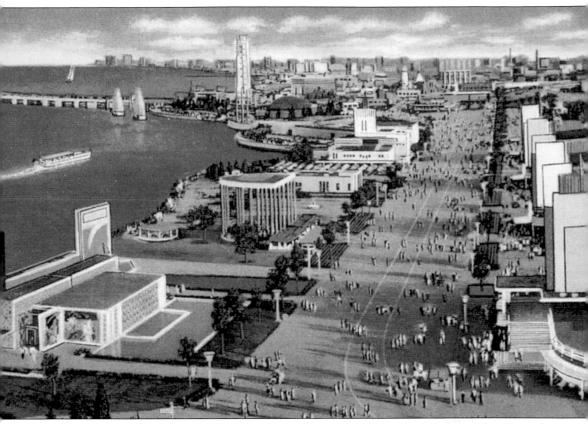

LOOKING SOUTH OVER THE WORLD'S FAIR GROUNDS. This postcard shows the General Exhibits Group in the foreground; also visible is the Time and Fortune Pavilion. Part of the success of the Fair was due to the ability of its Department of Promotions to reach masses of people through advertising efforts that went far beyond past promotional efforts. With advertisements in newspapers, magazines, featured "news" stories, brochures, and postcards, the Century of Progress World's Fair in many ways helped to usher in the advertising age. The celebrity of the Fair—industry—made this possible as print media became increasingly reproducible and available. (CT)

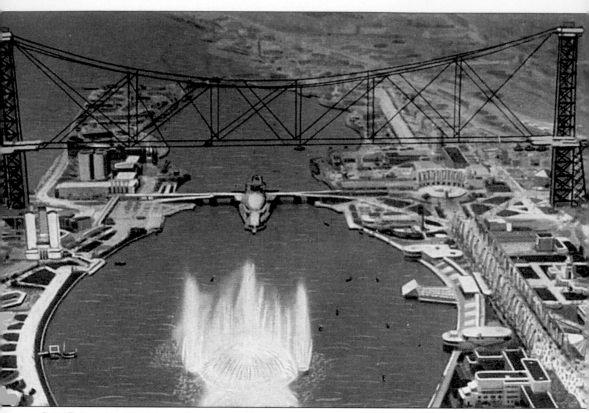

SKY RIDE AND LAGOON SHOWING CASCADE FOUNTAIN. After a walk south on the Avenue of Flags one would arrive at the Sky Ride, Lagoon, and Cascade Fountain. At this point on the fairgrounds, the purpose and message of the event was clearly in focus. An engineering triumph, industrial masterpiece, and exciting thrill, the Sky Ride offered a view of the grounds and an unparalleled experience.

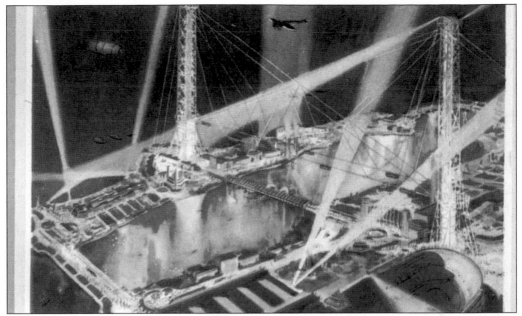

THE LAGOON AT NIGHT. This artist's rendering of an aerial view of the Sky Ride and Lagoon gives an idea of how brilliant the night scene was. Control over lighting was a crucial feature of the Fair, and after sunset a new world of attractions emerged. (VB)

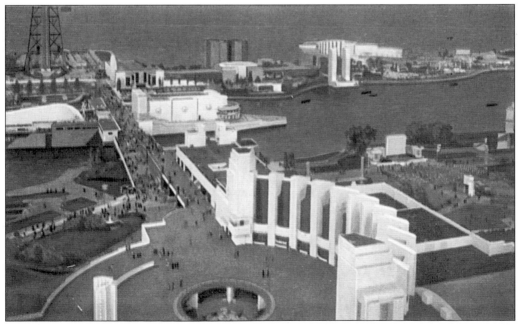

SIXTEENTH STREET BRIDGE. This bridge connected the Northerly Island to the mainland. On a stroll across it, Fair-goers passed both the Hiram Walker and Armour Company Exhibits, which were located on opposing islands attached to the bridge. (AC)

The universe is full of magical things,
patiently waiting for our wits to grow sharper.

Eden Phillpotts

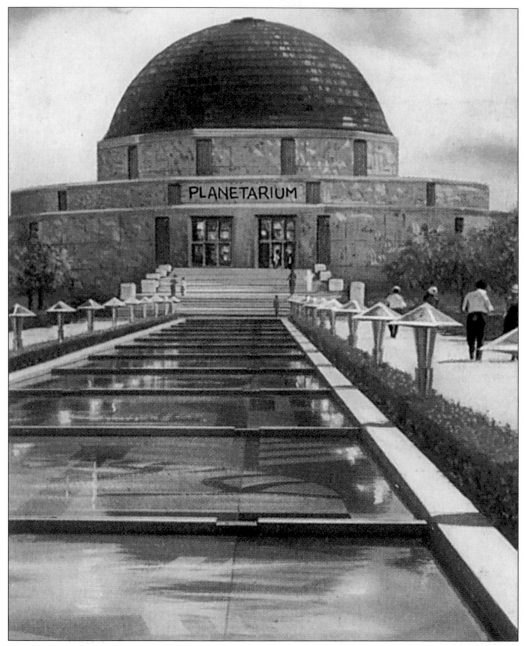

TERRAZO PROMENADE AND ADLER PLANETARIUM. Included as part of the Exposition, the Adler Planetarium allowed visitors to see the "Drama of the Heavens" at any given time. At the time of the Exposition, the Planetarium was the only one of its kind in the U.S. Today, it remains an incredible and awe-inspiring marvel of astronomical science. (AC)

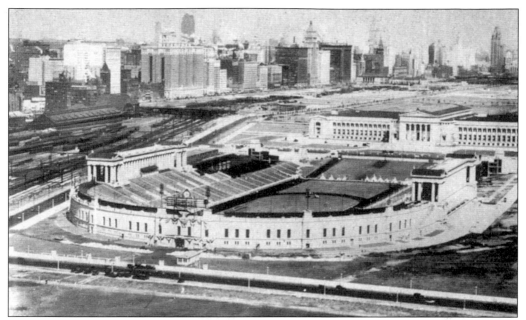

SOLDIER FIELD. Just east of the North Lagoon stood Soldier Field. From this view looking north, the Field Museum is visible in the distance. The historic field would see many striking changes to its form in later years. (SH)

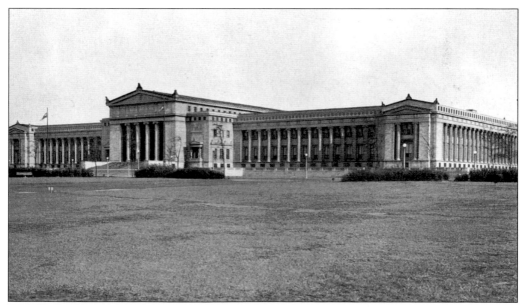

THE FIELD MUSEUM. Located at the north entrance of the Fair, the Field Museum allowed Fair-goers to journey through one of the world's greatest museums of anthropology and ethnology. (RM)

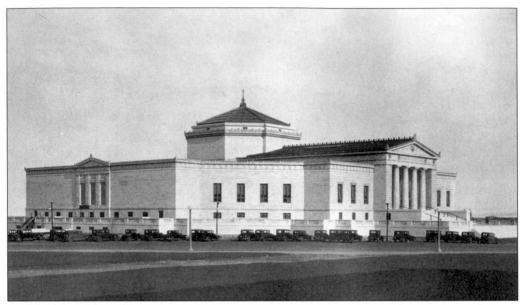

JOHN G. SHEDD AQUARIUM. Located within a stone's throw of the North Entrance to the Fair, the John G. Shedd Aquarium was home to a comprehensive and permanent marine life exhibit. The Shedd Aquarium remains one of the country's most respected marine centers. (RM)

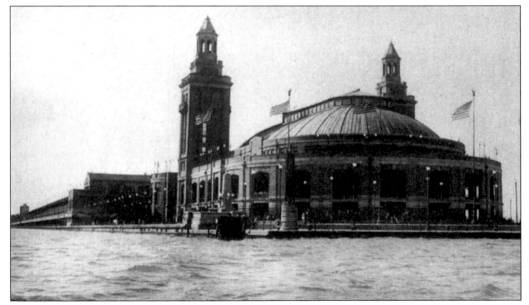

NAVY PIER. "A Playground and Lake Shipping Center of Chicago" reads this promotional Exposition postcard. Visitors from Great Lakes cities could take a steamer to Navy Pier, which was located just north of the Exposition. From there, smaller steamers and motor boats would transport visitors to the Fair. (SH)

THE HI-HO GOLF CLUB. Advertising their close proximity to the World's Fair and great amenities, such as rooftop golfing, the Stevens Hotel issued a postcard view book complete with both hotel and Fair images. The Stevens proclaimed it was "The Gateway to the Fair," with 3,000 rooms with baths for three dollars and up. The Stevens Hotel would later become the Chicago Hilton. (SH)

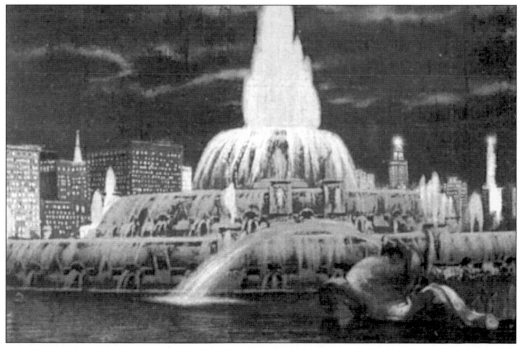

BUCKINGHAM FOUNTAIN AT NIGHT. Still a Chicago treasure, the Clarence Buckingham Memorial Fountain in Grant Park, although not on fairgrounds, was a sight to behold. The lighting possibilities were endless, as colored lights, in the style of the Fair, were used to illuminate the waters as they rose 70 to 90 feet in the air. The fountain is built from Georgia Marble and was a gift to the city by Kate Buckingham in honor and memory of her brother. (MVB)

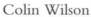

*The mind has exactly the same power as the hands;
not merely to grasp the world, but to change it.*

Colin Wilson

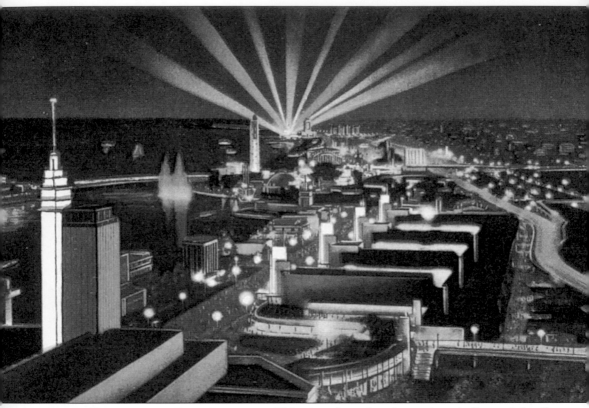

NIGHT VIEW OF THE FAIR GROUNDS. This view from the observation platform of the Sky Ride helps to put the Fair's scope, beauty, and theme into perspective. With magnificent lighting, a highly controlled environment, and scientific and industrial progress only made possible since the Second Industrial Revolution, the Chicago's World Fair of 1933-34 was truly the celebration of a century of progress. (CT)

Two

INNOVATORS AND INDUSTRY

SCIENCE FINDS—INDUSTRY APPLIES—MAN CONFORMS

*Science discovers, genius invents, industry applies, and man adapts himself to, or is molded by,
new things. Science, patient and painstaking, digs into the ground, reaches up to the stars, takes
from the water and the air, and industry accepts its findings, then fashions and weaves, and
fabricates and manipulates them to the uses of man. Man uses, and it affects his environment,
changes his whole habit of thought and living. Individuals, groups, entire races of men fall into
step with the slow or swift movement of the march of science and industry.*
-Official Guide Book 1933

A Century of Progress was an opportunity to show the world what science and industry had accomplished and how they had changed the world. There was no better way to illustrate these changes than through dynamic, living exhibits designed to show the complete process of creation, from scientific discovery to industrial production to everyday uses.

Past fairs were designed to show the magic of the final product, as they hosted competitions between exhibitors and often focused on previous achievements. The 1933-34 World's Fair was significantly different.

With a clear eye focused on how scientific discoveries and revolutionary industrial techniques of today could drastically alter the world of tomorrow, A Century of Progress provided a window into the laboratories and factories that were rapidly changing the world. Exhibitors did not compete for prizes, but worked to make their process completely clear, fully adopting the design aesthetic and message of the Fair.

A Century of Progress offered the visitor a clear understanding of how science and industry were changing lives and an opportunity for optimism in the face of the Great Depression. Innovation and Industry would not acquiesce, but rather adapt and grow stronger, all the while changing the world.

Progress lies not in enhancing what is, but in advancing toward what will be.

Kahlil Gibran

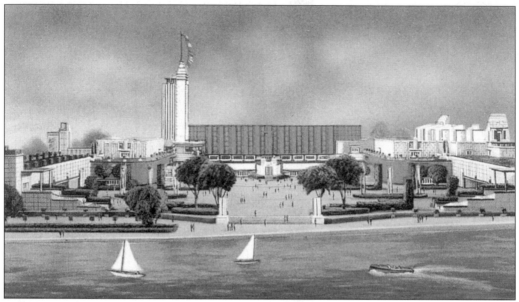

THE HALL OF SCIENCES. Divided into six sections: Mathematics, Geology, Biology, Chemistry, Physics, and Medicine, the Hall of Sciences was in many ways at the heart of the Fair's focus on progress and industrial advancement. For it is first the achievements and discoveries of science that lay a foundation for further development. (CT)

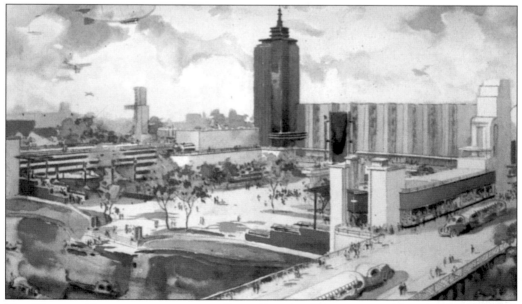

THE HALL OF SCIENCE IN WHICH THE BASIC SCIENCE EXHIBITS ARE DISPLAYED. This view of the Hall shows just how large it was, spanning 400,00 square feet, more than eight acres, the enormity of the building was matched by its exhibitions. (VB)

NIGHT VIEW OF THE HALL OF SCIENCES. With long beams of illumination, the carillon tower was a dramatic beacon against the night sky. In a showing of science's swift progression, the 1933 Fair was opened in dramatic form as scientists harnessed the rays of the star Arcturus through a telescope in Wisconsin and then transformed the beam into electric energy by means of a photoelectric cell, amplified it through radio and sped it back to Chicago to start the Fair's inaugural night scene. (RM)

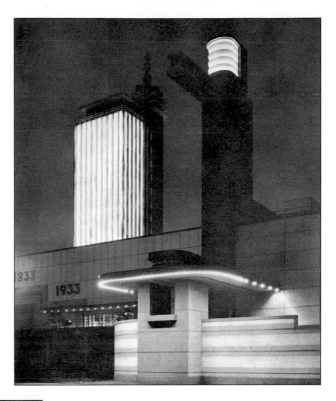

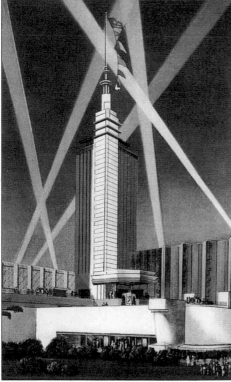

HALL OF SCIENCE AND CARILLON TOWER. The carillon tower stood 176 feet tall, and its bells would chime every quarter of an hour. (CT)

Science throws her treasures, not like a capricious fairy into the lap of a favored few, but into the laps of all humanity, with a lavish extravagance that no legend ever dreamed of.

Ernst Mach

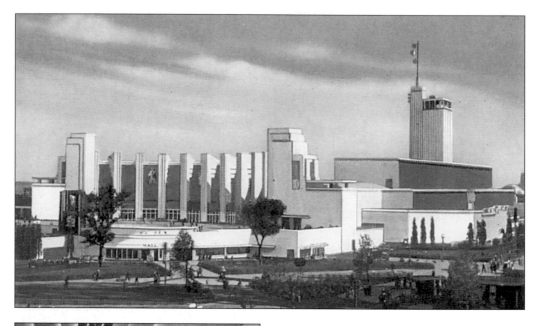

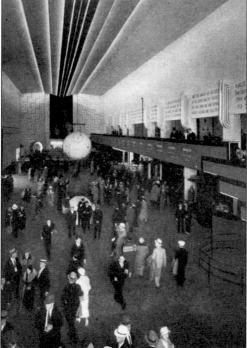

NORTH ENTRANCE, HALL OF SCIENCE. The description on this postcard reads: "This is the north entrance of the Hall of Science, a modern architectural masterpiece quite as much a marvel in construction and design as are the exhibits of science and industry it houses." (AC)

THE GREAT HALL OF THE HALL OF SCIENCES. The hall was 240 feet long, 60 feet wide with ceilings 57 feet high, and included quotes from notable scientists fitting to the exhibits' themes. Epitomizing the science and history of geology, the "Clock of Ages" could be found on the walls of the Great Hall, as could John Norton's "Tree of Knowledge," which mapped the Basic and Applied Sciences. (34GB)

Science without religion is lame, religion without science is blind.

Albert Einstein

THE HALL OF RELIGION. The 400-foot-long Hall of Religion housed exhibits of various denominations. Surrounding the entrance of the building were eight large murals dedicated to the aspirations of "Judaism, Christianity, Mohammedanism, Buddhism, Confucianism, Greek Mythology, Ancient Persian Worship, and the Worship of the American Indian." (AC)

HALL OF RELIGION FROM THE LAGOON. Inside the Hall of Religion a great many antique and artistic treasures were housed, from the Minoan treasures to the Great Chalice of Antioch. (OVB)

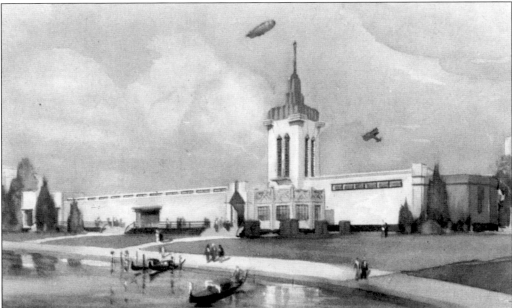

*A creative man is motivated by the desire to achieve,
not by the desire to beat others.*

Ayn Rand

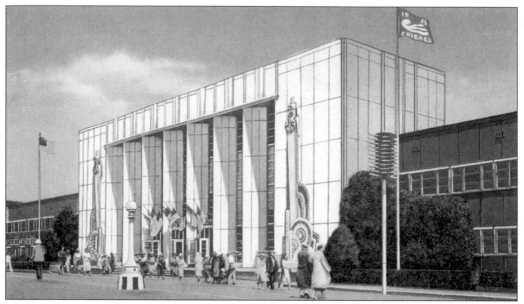

THE ADMINISTRATION BUILDING. The headquarters and official laboratory for A Century of Progress, the Administration Building was extremely modern in design and covered an area of 67,000 feet. The building's architects were Holabird & Root, Hubert Burnham, and Edward H. Bennett. (CT)

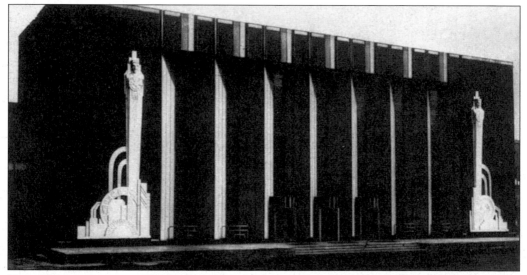

THE ADMINISTRATION BUILDING. One of the most striking features of the design of this building was the pair of figures flanking the entrance and symbolizing the theme of the Fair, science and industry. Science was symbolized by a zodiac wheel at the sculpture's base, industry by wheels and gears. The figures were designed by Alvin Meyer. (SH)

42

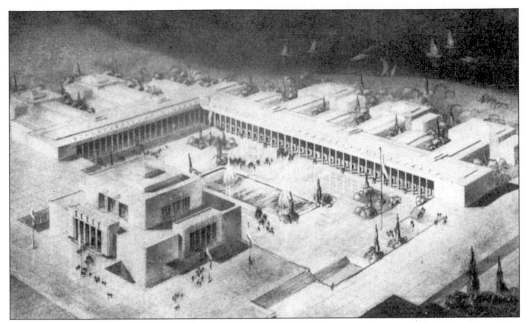

HALL OF STATES BUILDING. In an exhibit designed to both cut the cost of having each of the states provide their own building and illustrate the solidarity of the American union, A Century of Progress chose to have all of the states under one roof. The result was a parade of state history, products, and resources. (SH)

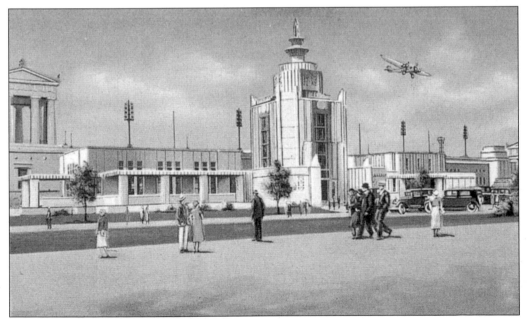

ILLINOIS HOST HOUSE. This building served as the official headquarters for Illinois state residents and guests of the state. It was located next to the Sears, Roebuck building, just south of the Fair's northwest entrance. (CT)

All progress has resulted from people who took unpopular opinions.

Adlai E. Stevenson

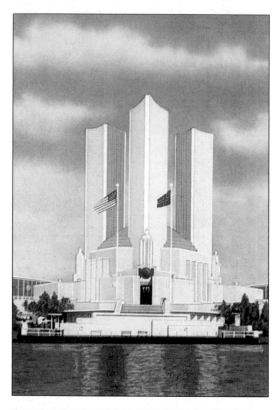

UNITED STATES GOVERNMENT BUILDING. Adjoining the Hall of the States stood the Federal Building with its three towers representing the three branches of Federal government: executive, legislative, and judicial. (AC)

FEDERAL BUILDING. The Federal Building stood 620 feet long and 300 feet wide with a rotunda 70 feet in diameter topped by a 75-foot dome. The three towers surround this dome. (CT)

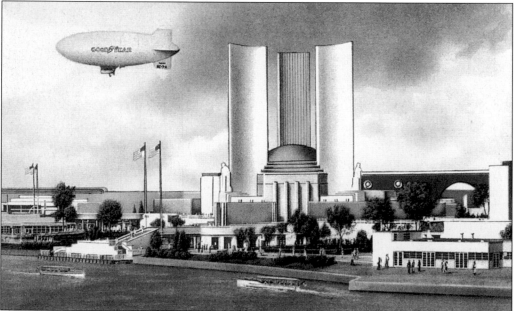

FIREWORKS DISPLAY ON THE LAGOON.
Twice a week a tremendous fireworks display
was held over the lagoon. Here we see the
Federal Building in the distance. (AC)

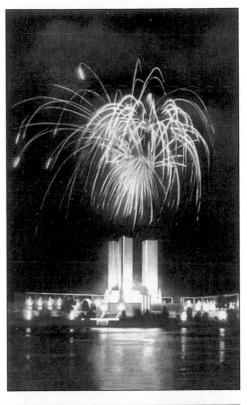

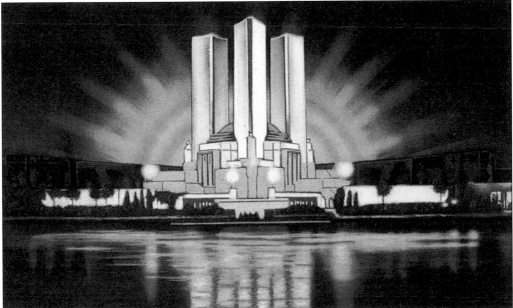

FEDERAL BUILDING BY NIGHT. The view of the building at night was quite spectacular. The
back of this postcard reads, "The sides of the triangles are the Hall of Thirty States, whose flags
and shields join with the unusual coloring of the building itself, and makes the interior court an
outstanding accomplishment in modern architecture." (CT)

There is a single light of science,
and to brighten it anywhere is to brighten it everywhere.

Isaac Asimov

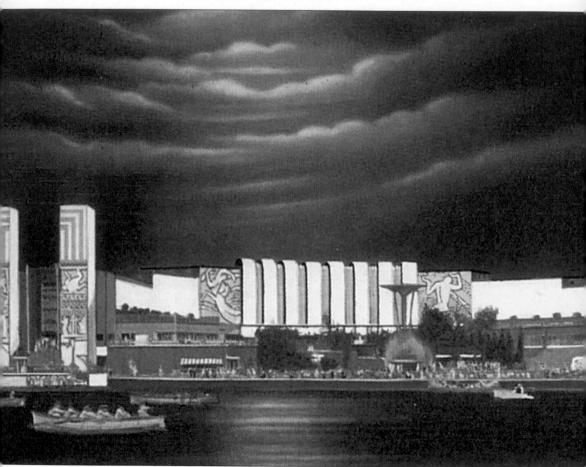

ELECTRICAL GROUP AT NIGHT. Developments in electronics incredibly altered life from 1833 to 1933. These advancements were evident throughout the Fair in the form of controlled space, lighting design, and sound. The carillon in the tower of the Hall of Science, for example, was played not by a person grabbing a rope to chime bells, but via telegraph wires.

Within the Electrical Group, one could find demonstrations on the generation, methods of distribution, and uses of electrical energy. (CT)

LIGHT. In the midst of the Electrical Building's horseshoe shape, overlooking the court, two bas-relief sculptures could be found, each 50 square feet in size. Light and Energy appropriately graced the exterior of the building.

The inscription on the sculpture representing light or stellar energy read: "Light is the beginning of all things. From the utmost ether it issues, shaping the stars, answering in its patterns to the majesty of creative thought."

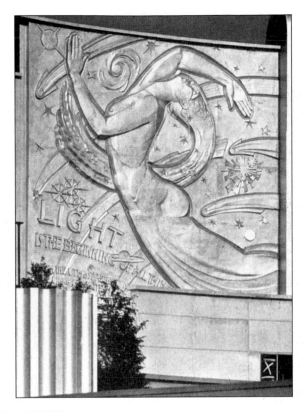

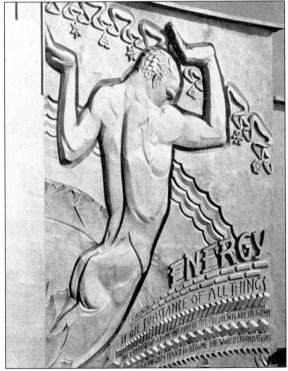

ENERGY. The inscription on the sculpture representing energy or atomic energy read: "Energy is the substance of all things—the cycles of the atoms, the play of the elements are in forms cast as by a mighty hand to become the world's foundation."

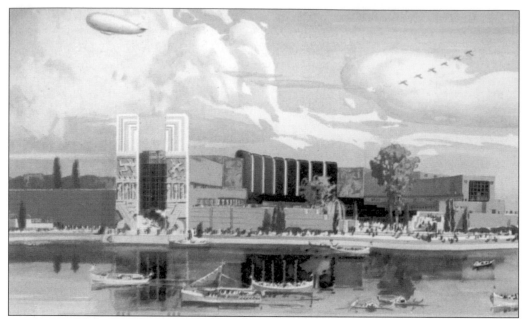

THE ELECTRICAL GROUP. The three buildings that made up the Electrical Group, located on Northerly Island, stretched for almost a quarter of a mile and formed a striking picture. Vividly designed in white, yellow, and red, they were a bright representation of electrical wonders. (VB)

AERIAL VIEW OF THE ELECTRICAL GROUP. From this aerial drawing of the Electrical Group it is easy to see just how sizable this exhibit was. The back of this card, made and distributed in advance of the Fair for advertising purposes, reads: "It will house the exhibit of electricity, telephone, telegraph, and radio: will be 1,200 by 300 feet, two stories high, and of striking modernistic design." (MVB)

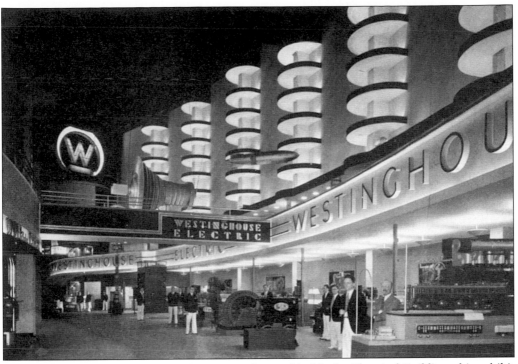

THE WESTINGHOUSE ELECTRIC COMPANY. Located inside the Electrical Building, this exhibit illustrated some of the many ways electric energy has been harnessed by man and industry for everyday use. (OP)

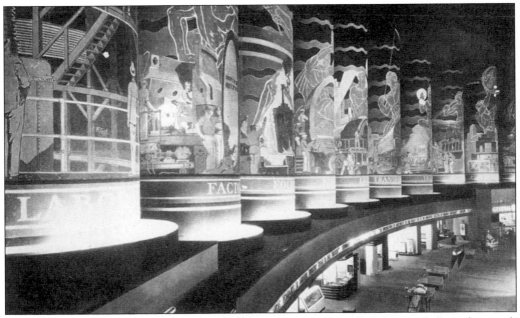

THE GENERAL ELECTRIC COMPANY MURAL. This mural, with drawings dedicated to such familiar industries as labor, factory, food, and transportation, celebrated the effect and influence of electric energy on these fields. (OP)

Without deviation progress is not possible.

Frank Zappa

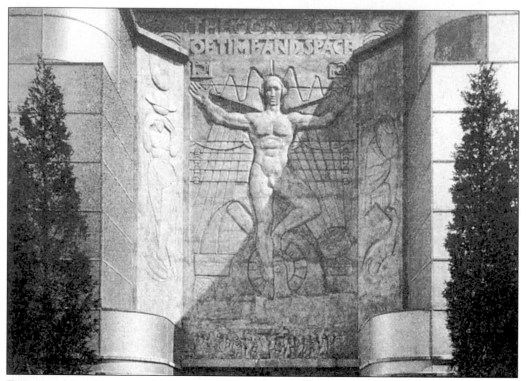

ENTRANCE TO RADIO AND COMMUNICATIONS BUILDING. A member of the Electric Group was the Radio and Communications Building, which housed exhibits focused on the wonders and achievements of the telegraph and telephone. Radio also had a huge impact on communication and quality of living; by 1933 two-thirds of American households had at least one radio. Interestingly, for the second year of the Fair the building's name was changed to Western Union Hall. (33GB)

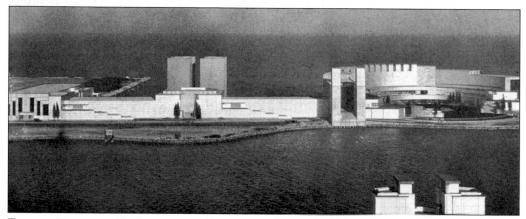

ENTIRE ELECTRICAL GROUP AND LAGOON. This angle faces east, looking at the group on Northerly Island. The Radio and Communications Building is located just left of center. (RM)

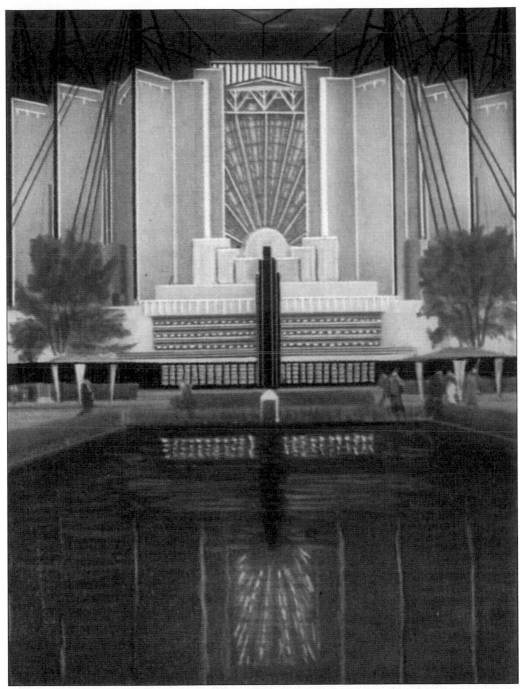

TRAVEL BUILDING AT NIGHT. An amazing architectural feat, the dome of the Travel and Transport Building was designed after the principle of a suspension bridge. Suspended by cables attached to 12 steel towers, 125 feet above the ground, the interior of the dome had a pillar-less diameter of over 200 feet. The dome was nicknamed "the dome that breathes," as it was made with joints fashioned to allow for expansion or contraction of up to six feet depending on the temperature and a roof that rose or sank up to 18 inches depending on snow fall or atmospheric pressure. (AC)

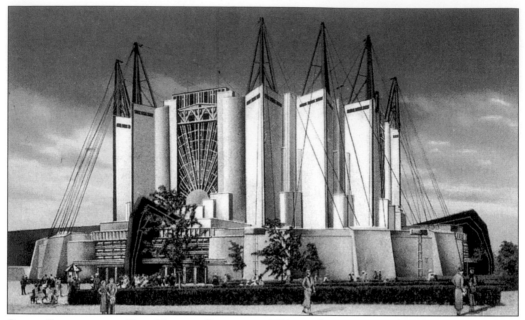

STEEL SUSPENSION, THE TRAVEL BUILDING. This card sent to "Mother and Dad" in New Jersey during the Exposition's second year appropriately bears this message: "We have and are seeing many very interesting things. The Fair is better than last year. The car is a peach and everything has been very pleasant so far. Hope you are well—Orion." (AC)

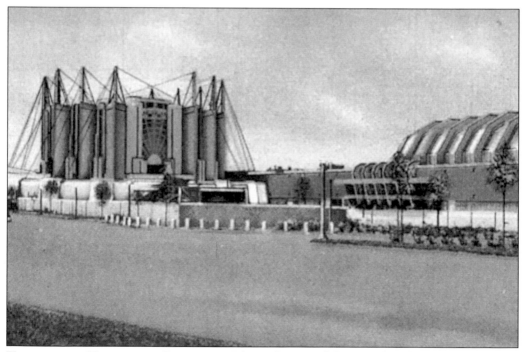

TRAVEL AND TRANSPORT BUILDINGS. The architects of the Travel and Transport Building were J.A. Holabird, Hubert Burnham, and E.H. Bennett. Clarence W. Farrier served as the architect of the Transportation Dome with Leon S. Moisseiff as consulting engineer. (MVB)

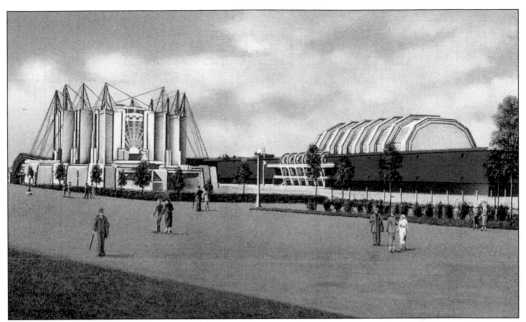

TRAVEL AND TRANSPORT. The interior of the Travel and Transport Building housed many of the most fascinating leaps and bounds in the history and advancement of the transportation industry. A reproduction of John Stevens' early locomotives, a stagecoach, a two-seat automobile from 1907, a high-wheel bicycle, and a multi-motored, all-metal airplane were just some of the transportation marvels to behold. (Curt Teich)

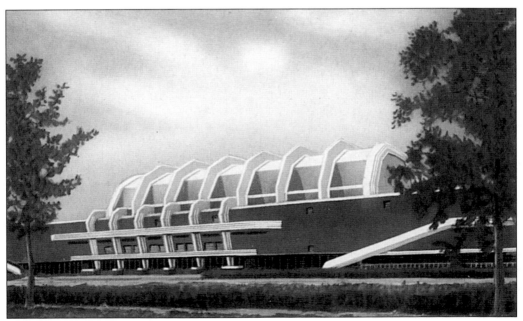

TRANSPORT BUILDING. The description on the back of this card reads: "The huge Transport Building contains everything that is interesting and educational pertaining to land, water, and air travel. Young and old alike revel in its wealth of exhibits." (AC)

The world is moving so fast that there are days when the person who says it can't be done is interrupted by the person who is doing it.

Anonymous

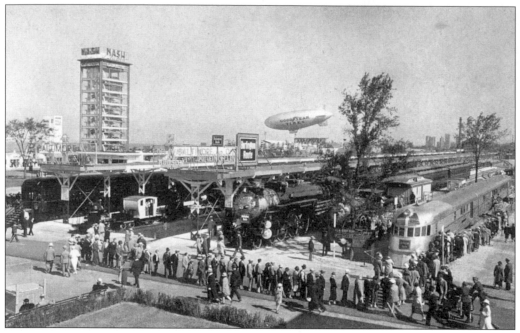

THE OUTDOOR RAILWAY TRAINS. South of the Travel and Transport Building on the outdoor tracks, "the swift advancements and evolution of transport in the past 100 years" was revealed. (OP)

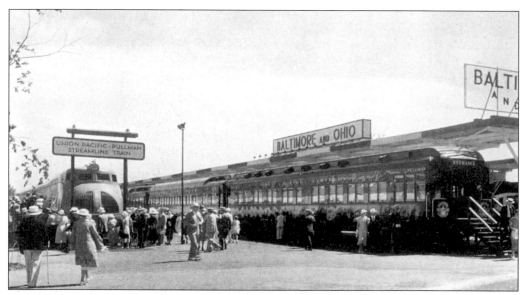

ANOTHER VIEW OF THE OUTDOOR RAILWAY TRAINS. Pictured here are the Baltimore and Ohio Railroad and the Union Pacific Pullman Streamline Train. The Streamline Train signaled a great advance in railroading as the new trains were far lighter in weight, could travel far greater distances before needing to be refueled, and could be temperature controlled. (OP)

54

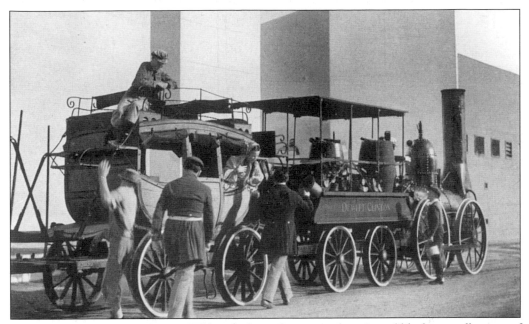

THE WINGS OF A CENTURY. With a legion of actors and an incredibly large collection of historic vehicles, the Wings of a Century pageant was created. Depicting scenes centered on covered wagons, steamboats, stage coaches, and the first flight by Wilbur Wright, the pageant was a historic and entertaining exhibit of transportation progress. (OP)

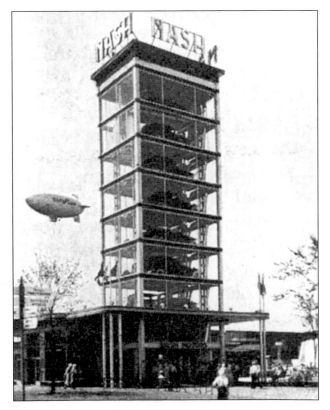

WHITING TOWER AND NASH MOTORS. This Whiting Automobile Parking Tower was 80 feet of enclosed glass. Inside, Nash Motors exhibited a constantly rotating chain of automobiles as the elevator went up and down to showcase the assorted vehicles. (34GB)

Nothing is particularly hard if you divide it into small jobs.

Henry Ford

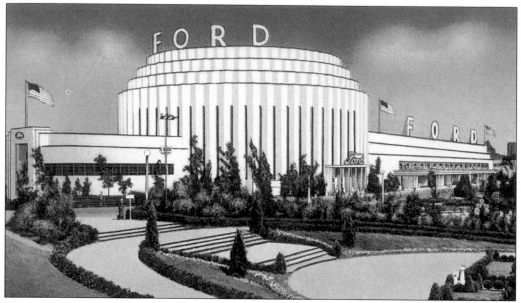

FORD BUILDING. The Ford Building, 900 feet in length, 10 stories high in the center, with a dome 200 feet in diameter representative of a giant cog in a gear, was designed by Albert Kahn of Detroit and was the largest building ever constructed for a World's Fair. In the gardens surrounding the Ford Exposition, the Detroit Symphony could be found providing the crowds with music. (CT)

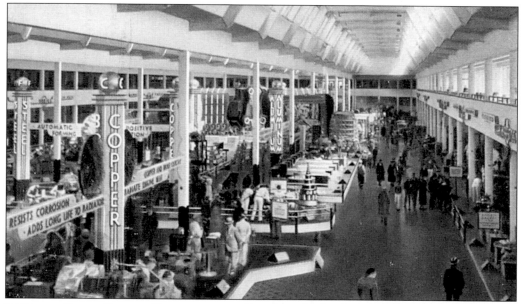

INTERIOR FORD MOTOR COMPANY AND EXHIBIT. At the time of the Fair, the Ford Motor Company's exhibit contained the largest photo mural in the world, 200 feet high by 600 feet wide. (AC)

Obstacles are those frightful things you see when you take your eyes off your goal.

Henry Ford

FORD MOTOR COMPANY AT WORK. In keeping with the Fair's focus on industrial exhibits in action, the Ford Motor Company traced "the evolution of the Ford V-8 automobile from mine, forest, and farm, through manufacturing processes into finished parts. Each exhibit [was] a living colorful display illustrating the combining of human ingenuity with basic materials to build the Ford car." (AC)

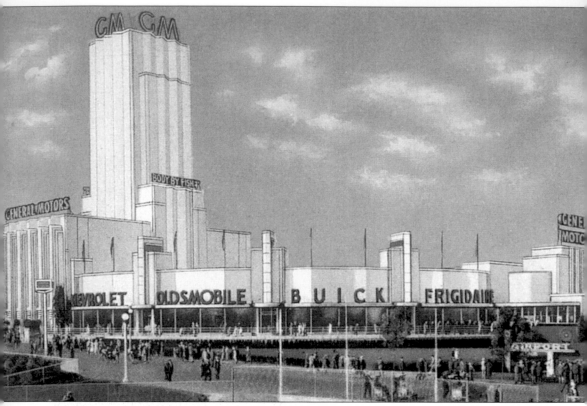

GENERAL MOTORS BUILDING. Built at a cost of approximately $3 million, the GM building also served as a working factory. Visitors to the Fair could witness the entire automobile assembly process of a Chevrolet from chassis frame to the car being driven off the assembly line complete with a full tank of gas. Cars assembled during the Exposition were then sold as part of the regular output of General Motors. (CT)

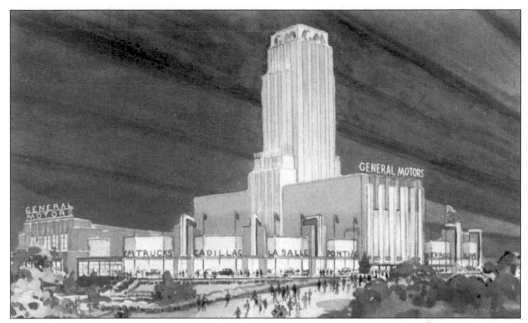

GM. The GM Building, which measured 429 feet long and 306 feet wide, was topped by a tower that reached 177 feet into the air. According to the 1934 Guide Book, the building used enough electric power "to pump water for a city of 25,000" people "or provide home and street lighting for a city of 7,500." (VB)

GM ADVERTISEMENT. This ad and invitation to the GM exhibit gives an idea of how massive the GM Corporation was. The companies listed under its umbrella listing included: Chevrolet, Pontiac, Oldsmobile, Buick, La Salle, Cadillac, Bodies by Fisher, GMC Truck, Yellow Coaches, General Cabs, AC Spark Plugs, Hyatt Roller Bearings, Guide Lamps, Delco, Delco–Remy, New Departure, Winton Engine, Moraine and Inland Products, Frigidaire Refrigerators, Coolers, and Air Conditioners, Delco Household Appliances, General Motors Acceptance Corporation, General Exchange Insurance Corporation, and General Motors Export Company. (34GB)

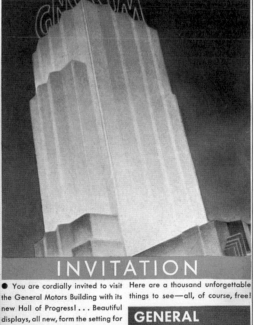

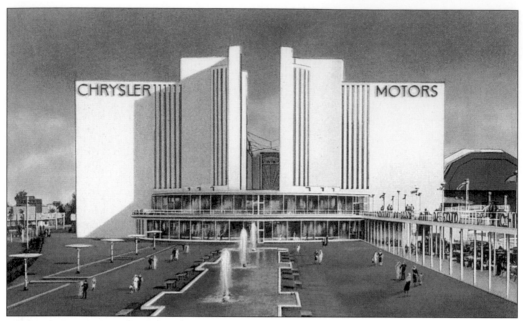

CHRYSLER BUILDING. In the form of a Maltese cross with four 125-foot-high pylons and an open center, stood the Chrysler Building. Inside, demonstrations of actual automobile manufacturing as well as graphic and animated displays told the Chrysler tale. (CT)

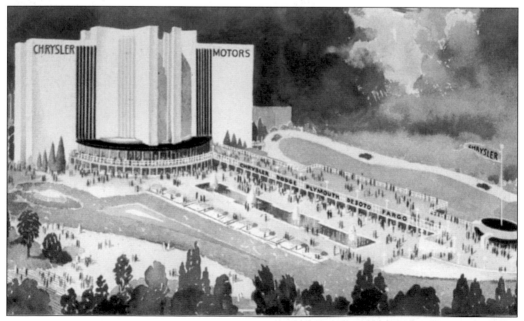

CHRYSLER GROUNDS. Outside the Chrysler Building, an automobile driving and testing exhibition track could be found. Free exhibits were given hourly. (VB)

You get the best out of others when you give the best of yourself.

Harvey Firestone

FIRESTONE ADVERTISEMENT. The sizable Firestone exhibit, located just north of the Twenty-Third Street Entrance, showed the complete process of tire manufacturing. (34GB)

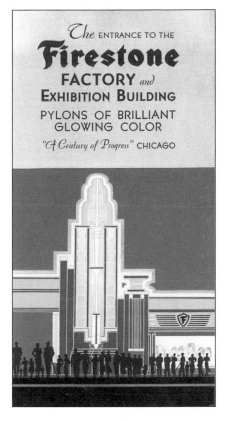

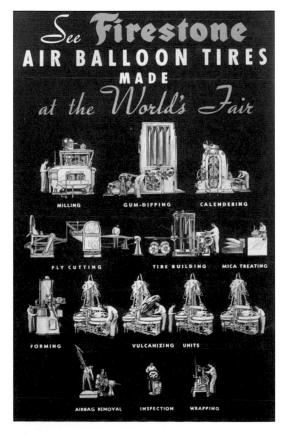

FIRESTONE PROCESS. Beginning with the crude rubber harvested from plantations in Liberia, Africa, to the final inspection and wrapping of the completed tire, visitors to the Firestone exhibit could witness the entire process of how their tires were made. (34GB)

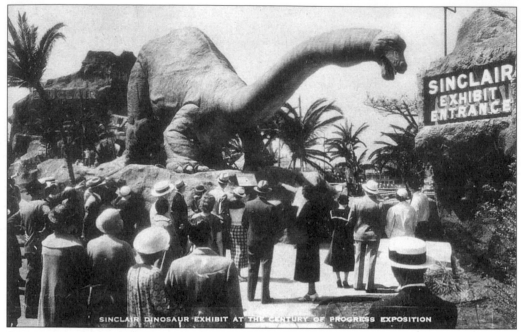

SINCLAIR DINOSAUR EXHIBIT AT THE CENTURY OF PROGRESS EXPOSITION

SINCLAIR DINOSAUR EXHIBIT. The Sinclair Refining Company's Dinosaur Exhibit was the first attempt to create "out-of doors, a portion of the earth's surface and animal life as they existed 100 million years ago. This life-sized Brontosaurus model recreates the largest animal in the world. In life he bulked 40 tons and was 70 feet long." The exhibit served to both titillate the viewer and explain the scientific and industrial process of oil refinement. (Sinclair Refining Co.)

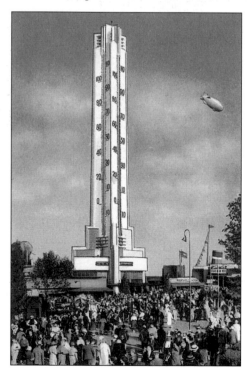

THE GREAT THERMOMETER. Havoline's giant thermometer was 227 feet high, the largest and only one of its kind in existence. The thermometer could be seen from all over the fairgrounds and the temperature could easily be read on any of its three faces. The numbers on the thermometer were ten feet high and the neon lighting in the glass tubing made it easy to read at night as well. (CT)

Reasonable people adapt themselves to the world.
Unreasonable people attempt to adapt the world to themselves.
All progress, therefore, comes from unreasonable people.

George Bernard Shaw

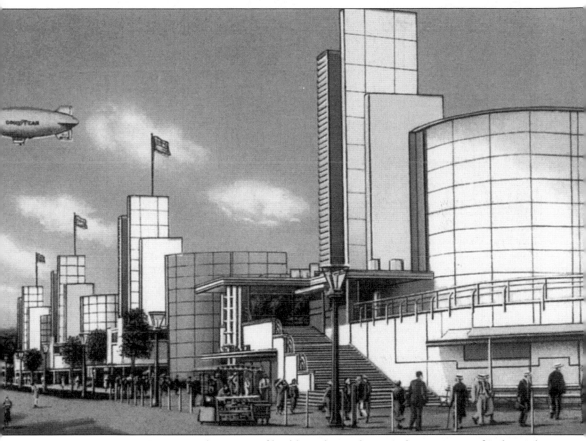

GENERAL EXHIBITS GROUP. This series of buildings housed a varied assortment of industrial exhibits including housing, graphic arts, office supplies, cosmetics, leather, sporting goods, and jewelry. (CT)

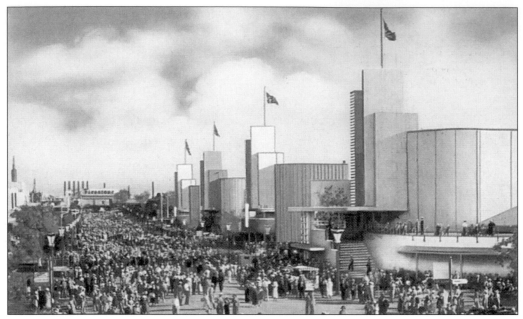

VIEW OF THE GENERAL EXHIBITS GROUP. Planned to tell the story of many varied industries, the General Exhibit building was 985 feet long and 2 stories high, with a total of over 5 acres of floor space. The group included exhibits on the purpose of oil in a motor, Gutenberg's Print Shop, various Business Machines, the process of diamond mining, and filling up tubes with toothpaste. (CT)

IBM. "Contributing to world business progress" was the International Business Machine Corporation, which displayed its wide array of sorting, filing, tabulating, and typing business machines. This company would later become a pioneer in the next industrial revolution, the computer industry. (33GB)

*Competition is not only the basis of protection to the consumer,
but it is the incentive to progress.*

Herbert Hoover

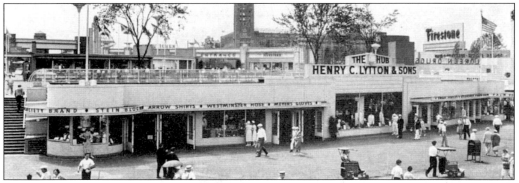

HENRY C. LYTTON AND SONS. Located near the Firestone exhibit and Twenty-Third Street, the Henry C. Lytton and Sons shop sold "women's, misses', men's, and boys' apparel and accessories" as well as sporting goods. (34OP)

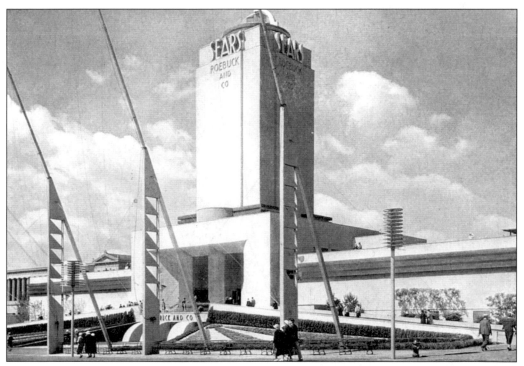

THE SEARS AND ROEBUCK BUILDING. Forever an icon of Chicago, Sears, Roebuck and Company was represented at the Fair by an impressive building located at the end of the Avenue of Flags, which offered visitors such amenities as "bureau of information, registration, telephone and telegraph offices, indoor lounge, and spacious roof terraces with easy chairs overlooking the lagoon." Next to the Sears and Roebuck building there was a bungalow completely outfitted by the retailer. (33OP)

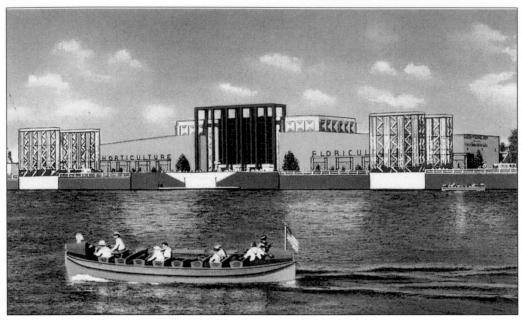

HORTICULTURE BUILDING. Surrounded by four acres of lakeside gardens, the horticultural exhibit was maintained by the Society of American Florists and was changed with the seasons. (CT)

A CORNER OF THE HORTICULTURAL AREA. A peaceful spot on the landscaped horticultural grounds might have made an ideal spot for contemplation, revelry, or reflection. (33GB, photo by Mario Scacheri.)

*The test of our progress is not whether we add more
to the abundance of those who have much, it is whether
we provide enough for those who have little.*

Franklin D. Roosevelt

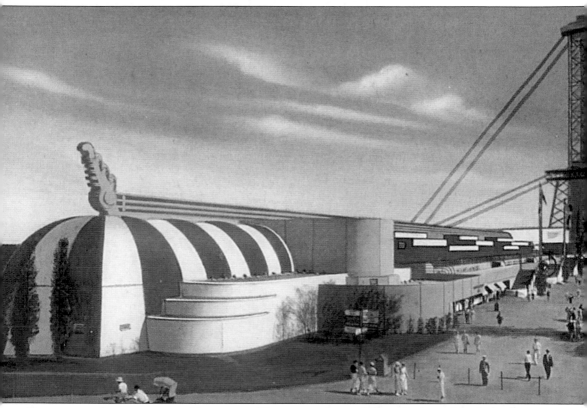

FOODS AND AGRICULTURAL BUILDING. "Farm operations exhibits, displays of foods, both in their raw state and ready for the table, exhibits of farm machinery, of food manufacturing processes and of food distribution, are seen here," according to the 1934 Guide Book.

The exhibits in this building were designed to show how food was produced, packaged, and prepared. Many of these exhibits were designed with the lady of the house in mind. "A canning demonstration shows the housewife how to can her food at home in tin." –From the *1934 Official Guide Book to the Fair.* (Photo-CT)

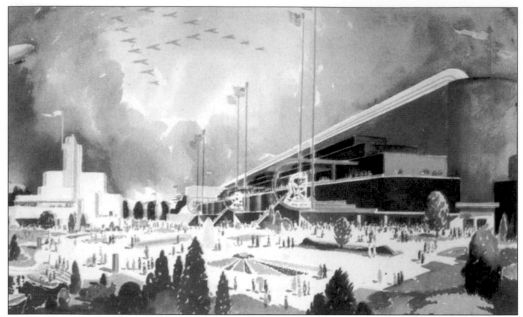

ANOTHER VIEW OF THE FOOD AND AGRICULTURE BUILDING. The building also housed an automatic soft drink bottling plant, hive of real bees, and history of sugar manufacturing, to name just a few exhibits. (AC)

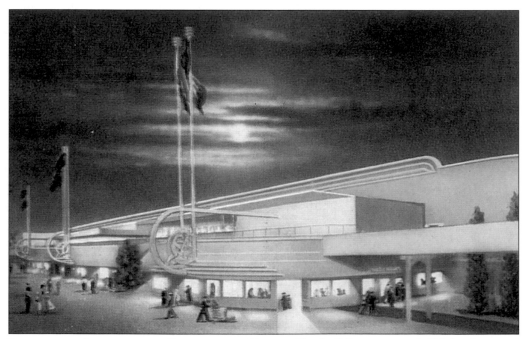

FOODS AND AGRICULTURE BUILDING AT NIGHT. The building measured 658 feet long and was designed by architects E.H. Bennett and Arthur Brown Jr. (VB)

DAIRY BUILDING. The Brookhill Dairy and barn demonstrated the most modern methods of milk production and sanitation. The cows, which were milked hourly, were housed behind plate glass partitions so that visitors could watch the milking process before moving on to see the entire bottling process. There was even a dairy restaurant and lunch counter where visitors could snack on the items they saw produced. (MVB)

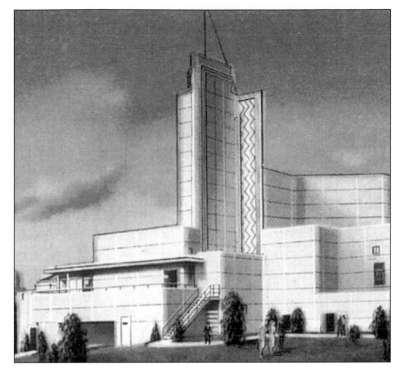

POULTRY EXHIBIT. These rows of hen houses accommodated some of the world's fanciest of chickens. This is also the site of the International Egg Laying Contest were entrants from 28 states and 5 other nations competed for the championship. During the 1933 Fair, the contest began a month before the May opening and lasted until two days before its close in November. (33GB)

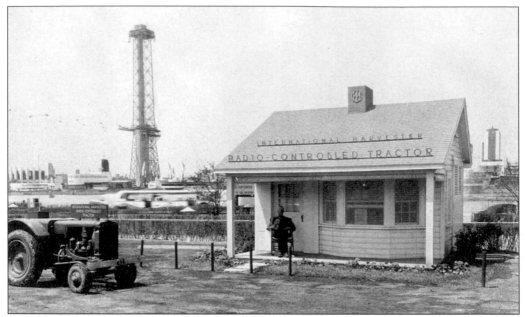

INTERNATIONAL HARVESTER EXHIBIT. Just west of the International Harvester Building and Farm Machinery Hall, the driverless, radio-controlled farm tractor was demonstrated. Inside the Hall, farm machines were exhibited and a moving, "breathing," mooing, and constantly lactating mechanical cow was displayed. (33GB)

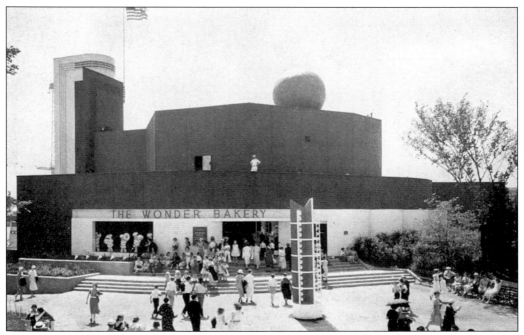

WONDER BAKERY. The first bakery to truly perfect assembly line bread making, the Wonder Bakery exhibit showed bread baking—scientifically. From automatic weighing, measuring, and mixing, to the bread being placed in the oven by conveyor, sliced, wrapped, and loaded on the delivery truck, the Wonder breads were never touched by human hands. (34OP)

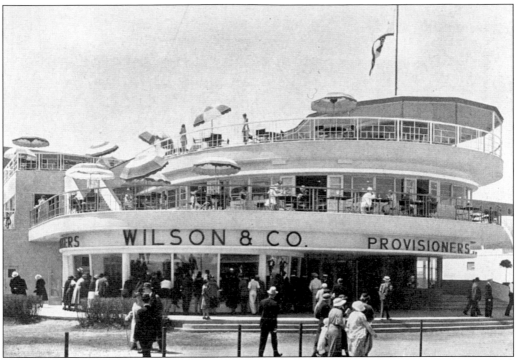

WILSON & COMPANY. Sanitary, scientific meat packaging was the main attraction at the Wilson & Company exhibit, but the processing plant also included the packaging of soap, cosmetics, gelatine, insulated materials, glue, and tallow. The 1934 Guide Book states of this exhibit, "Girls in spotless uniforms wrap and pack the bacon as it flows from the machine." (34OP)

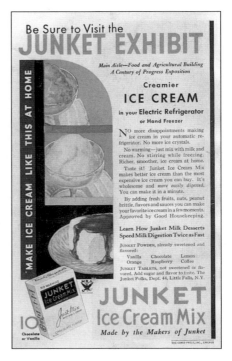

JUNKET ICE CREAM. This advertisement for Junket Ice Cream and the Junket Exhibit was prominently featured on the back of both the 1933 and 1934 Guide Books. Visitors to the exhibit could get a free taste of Junket in the main aisle of the Foods and Agriculture Building. For 10 cents customers could purchase a package of Junket, add it to milk, and have a creamy ice cream treat. (34GB)

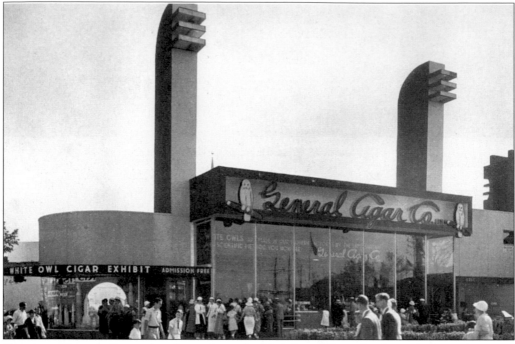

GENERAL CIGARS COMPANY. Located on the 23rd Street Plaza, the General Cigars Company exhibit housed an operational factory that showed the manufacturing of White Owl Cigars. (34 OP)

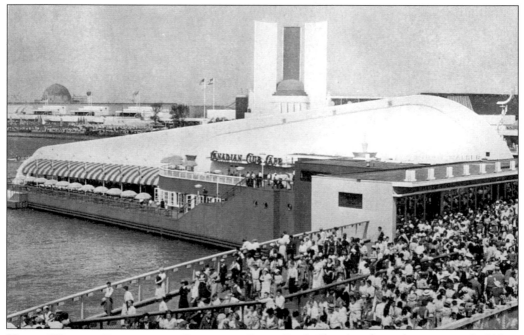

HIRAM WALKER EXHIBIT AND CANADIAN CLUB CAFÉ. Showing the entire process of whiskey manufacturing from raw grain to the packaged product, the Hiram Walker Exhibit featured a model of a modern distillery. Visitors to the Canadian Club Café on the first floor had much to celebrate as prohibition was repealed in April of 1933, just in time for the Fair. (34GB)

Progress always involves risk;
you can't steal second base and keep your foot on first base.
Frederick B. Wilcox

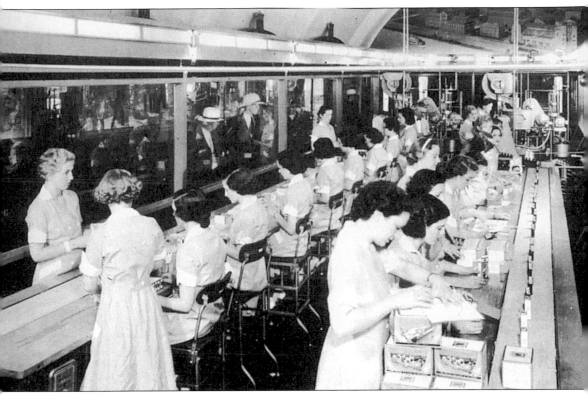

BOTTLING LINE AT THE HIRAM WALKER EXHIBIT. This view shows the final packaging stage of production at the plant. On-lookers are visible behind the glass partition to the left of the photo. The back of this card lists the various places throughout the Fair where Canadian Club could be purchased, including the Belgian Village, Adobe House Restaurant, Midget Village, and Walgreen Stores.

NOW RELIEVE A BAD HEADACHE IN FEW MINUTES

Quick Dissolving Property of **BAYER ASPIRIN** *Starts Relief 3 or 4 Minutes After Taking*

Genuine **BAYER ASPIRIN**

BAYER ASPIRIN. This advertisement stated: "Due to important scientific developments in the world-famous Bayer laboratories, almost INSTANT relief from headaches, neuralgia and rheumatic pains is being afforded." (34GB)

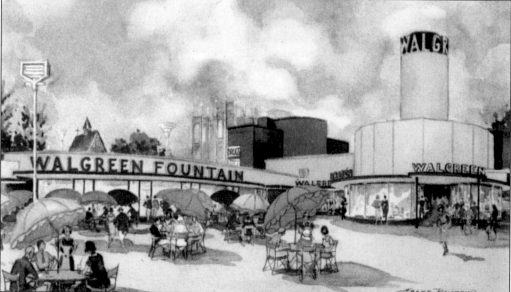

WALGREEN FOUNTAIN. With drug stores located at four points throughout the Fair, the Walgreen Company was beginning to lay a foundation on every corner of the American landscape. The building also included a fountain lunch, café service, and indoor and outdoor seating. (VB)

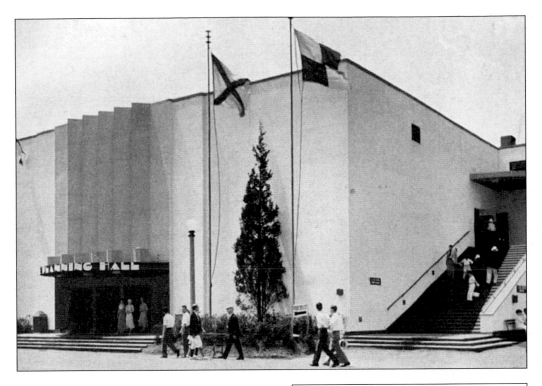

HOME PLANNING HALL. Dedicated to showing the advancements of home management (heating, plumbing, air conditioning, refrigeration, home equipment, household and building materials), the Home Planning Hall included various tests given to household materials and machines. Paints were speedily weathered, vacuum cleaners tested, and refrigerators explained. (34OP)

GAS INDUSTRY HALL. Here the story of the use and function of gas in the home was told. From gas cooking shows illustrating the place of gas in the kitchen to water heaters and house heating exhibits, the Gas Industry Hall illustrated and explained gas energy, something easily taken for granted today. The American Gas Association was one of the major exhibitors in the hall. (33GB)

I'm a big believer in the never-ending possibility of everything.

Jonathan Hoenig

THE GIANT SHOWER BATH. This giant reproduction of the most modern of shower designs was 45 feet tall and was fashioned by the Crane Company. In order to strikingly note the contrast and developments in bathing and plumbing, the antique bathrooms and tubs could also be found within the building. (34GB)

THE GLASS BLOCK BUILDING. Built by the Owens-Illinois Glass Block Company, this building and tower housed a collection of antique glassware and a miniature glass manufacturing plant. At the time, glass blocks were a novel invention, while today they are prevalent, affordable, and accessible.(33OP)

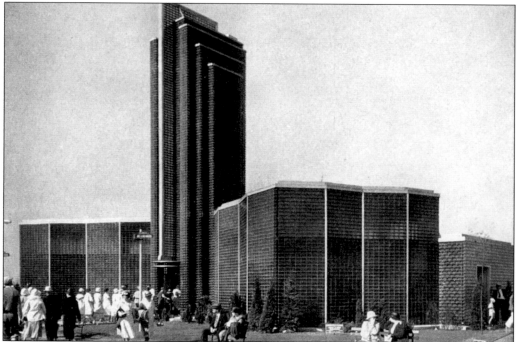

Everyman builds his world in his own image. He has the power to choose,
but no power to escape the necessity of choice.

Ayn Rand

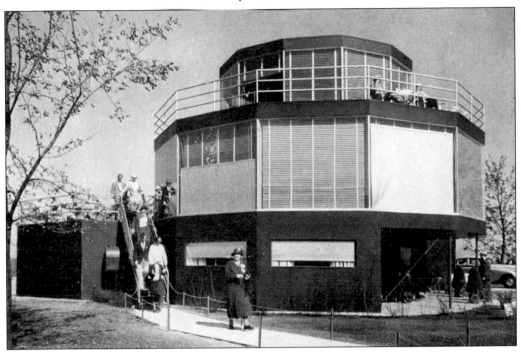

THE HOUSE OF TOMORROW. Built to indicate the possible future of housing, the "House of Tomorrow" was a circular glass and steel house consisting of three drums layered atop one another. The bottom layer consisted of a laundry area, workshop, and hangar (as the resident of the "House of Tomorrow" owned his or her own plane). The middle level, the living space, was all glass, yet no windows opened, and temperature was controlled via air conditioning. And the top floor was the solarium and was surrounded by a roof terrace. All piping and wiring was contained together in the center of the structure. (33OP)

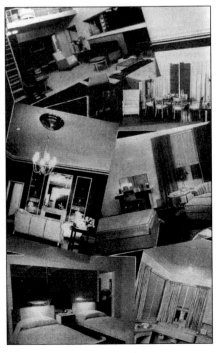

MODERN INTERIORS. Each of the 11 model homes displayed at the Fair (Brick Manufacturer's Home, Armco-Ferro Enamel House, General Houses, Inc., House, Good Housekeeping-Stransteel House, Rostone House, "Design for Living," Masonite House, Lumber Industries House, "House of Tomorrow," Florida Tropical House, and W.&J. Sloane House) was equipped with completely modern furnishings. This montage shows just a few of the many rooms displayed. (34GB)

You see things as they are and ask, "Why?"
I dream things as they never were and ask, "Why not?"

George Bernard Shaw

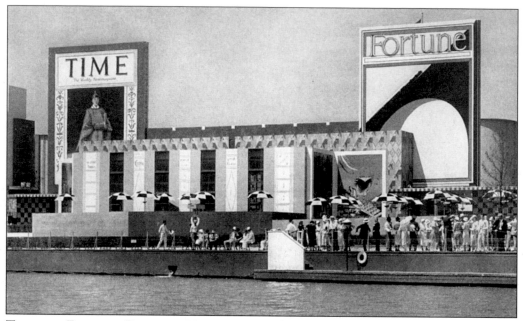

TIME AND FORTUNE BUILDING. Housing 2,000 different magazines from all over the world, the Time and Fortune Building, with its reading room lounge and deep comfortable chairs, might have been a nice place to catch up on some reading, or at least a good spot to stop for a rest. (OP 33)

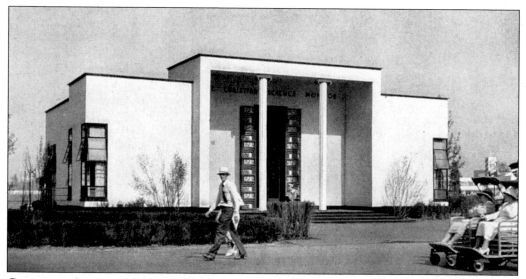

CHRISTIAN SCIENCE MONITOR BUILDING. The 2,600-foot air conditioned reading room was certainly an attraction of the Christian Science Monitor Building. While inside, visitors also learned about the publication and distribution process of the paper as well as news gathering and advertising methods. (OP 33)

Life without industry is guilt, industry without art is brutality.

John Ruskin

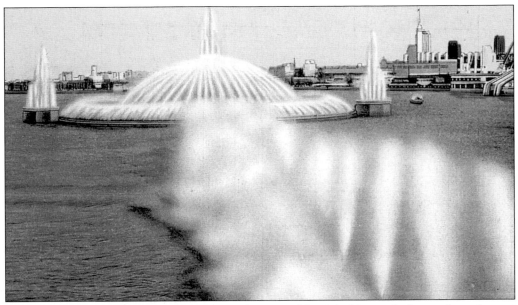

A CENTURY OF PROGRESS FOUNTAIN. At the time of the Fair this was the largest fountain ever constructed. It measured 670 feet, and 68,000 gallons of water flowed from its jets every minute. The fountain was lit with green, red, amber, blue, or white submarine and searchlights that extended well into the air creating an awe-inspiring night view. (AC)

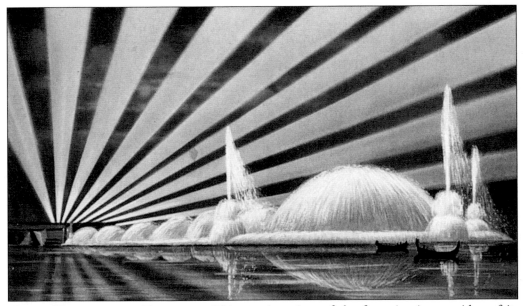

NIGHT VIEW OF THE FOUNTAIN. This evening view of the fountain gives an idea of its impressive size. The two small boats in the postcard's right foreground are representative of the taxi boats that would cruise the lagoon carrying as many as 20 people. (CT)

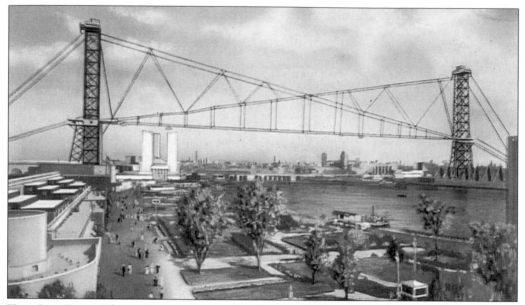

THE SKY RIDE. The steel towers supporting this amazing structure stood 628 feet high, and at the time were the tallest man-made structures west of the Atlantic coast. It was possible to head to the tops of these towers and observe the Fair's grand layout from a bird's-eye view or cross the lagoon, 210 feet above the ground. (CT)

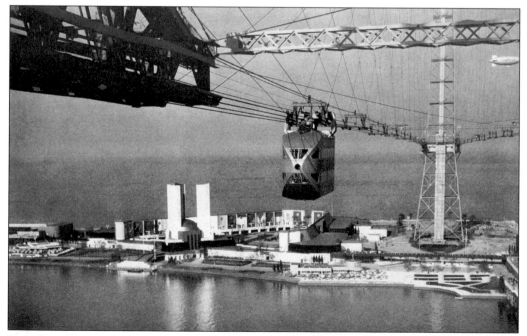

THE SKY RIDE AND ROCKET CAR. From end to end the Sky Ride was an impressive 1,850 feet long. The Sky Ride was made possible through the work of five companies: Great Lakes Dredge and Dock Company, Mississippi Valley Structural Steel Company, Inland Steel Company, Otis Elevator Company, and John A. Roebling's Sons Co. According to the *1934 Guide Book of the Fair*, 2,616,389 people crossed in the observation cars in 1933. (33OP)

Any sufficiently advanced technology is indistinguishable from magic.
Arthur C. Clarke

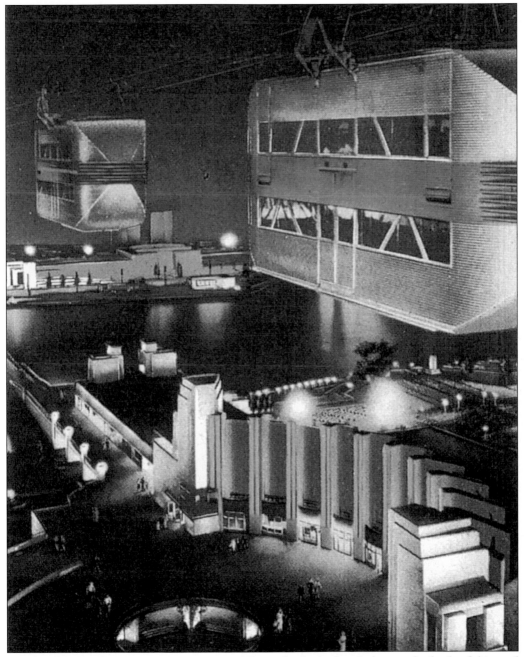

ROCKET CARS CROSSING THE LAGOON. The enthusiastic description on the back of this card states: "Here is the supreme thrill of a lifetime—a ride on the Sky Ride, an unequalled view of the Fair Grounds and the City of Chicago from rocket cars suspended beneath the rails. Approximately 1,800 feet apart, the rocket cars shoot across this space at a level of 210 feet." (CT)

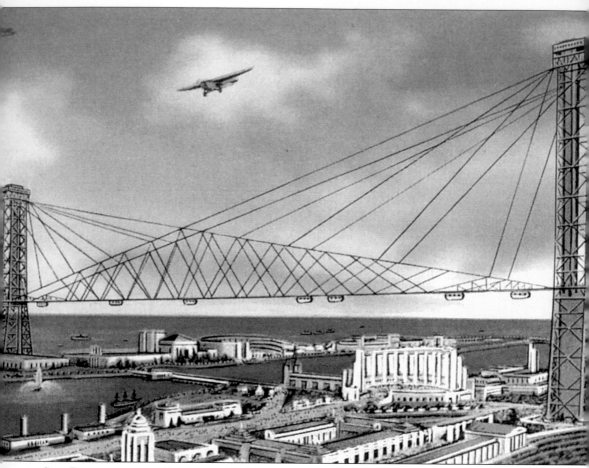

Sky Ride over the Lagoon. (CT)

Three

ALL THINGS BAZAAR

Fun reigns in the Fair. Nor is it confined merely to the strip exactly 1,933 feet long that is devoted to the barker, the blare, and the ballyhoo. It is everywhere—wholesome fun and fascinating adventures for those who would drop their cares and don the cloak of conviviality.
-1933 Guide Book to the Fair

At its core, before science, industry, or architectural achievement, the Fair was fun. In its scientific experiments, tours through world villages, eateries, and freak shows, the visitors' enjoyment was always in focus. With fun and amusement much needed luxuries during the height of the Great Depression, the 1933-34 World's Fair provided a great deal at a fairly reasonable price.

But what was fun for one was not necessarily fun for all. Parts of the Fair's midway were not for the faint of heart. Sword swallowers, body-twisters, and the Flea Circus might have been enough to turn Granny's stomach, but the offerings were varied and there was something for everyone to enjoy and disdain.

One of the most popular and controversial shows did just that. Sally Rand's fan show in the Streets of Paris offered a titillating peep show that attracted huge crowds. But not everyone thought it a worthy or scientific exhibit.

Less than two months after the Fair began, a case was brought to court regarding the Fair's display of performances considered "lewd, lascivious, and degrading to public morals." The judge in charge of the case, the Hon. Joseph David, dismissed it, stating: "There is no harm and certainly no injury to public morals when the human body is exposed, some people probably would want to put pants on a horse."

Despite the controversy that inevitably accompanies the risqué, the thrills of the Fair were a welcome aversion to the harsh realities of the 1930s. But the times were starkly different. Looking through the lens of today many of the exhibits seem politically incorrect, blatantly racist, and even shockingly offensive. Exhibits on the Midway unapologetically objectified people, and Fair-goers paid good money to watch; they were all willing participants.

Regardless of the politics, the Fair was a tremendous success. It offered a moment's escape and a wonderful release from the often harsh realities outside its entrance gates. People went to the Fair to have fun, and that, they did.

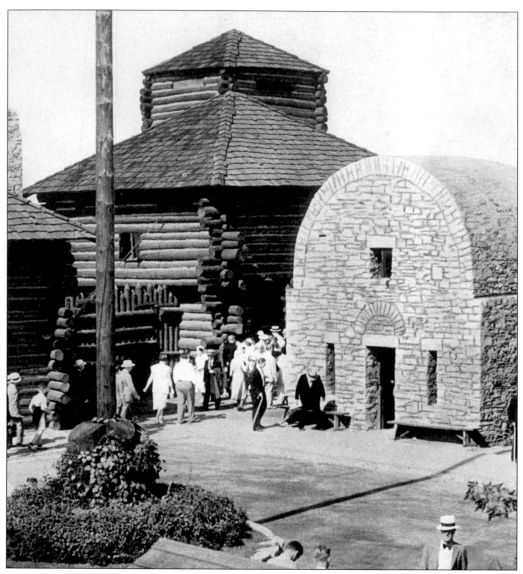

FORT DEARBORN. In 1803, soldiers landed at the mouth of the Chicago River with instructions to build a fort and hold the surrounding six mile swampy area—what would later become Chicago's downtown.

Life around Fort Dearborn remained fairly peaceful until 1812. As the War of 1812 became increasingly close at hand with the British capture of Fort Mackinac and the Fall of Fort Detroit, Cpt. Nathan Heald was given orders to lead his group of soldiers, women, and children, from Fort Dearborn to Fort Wayne. He did so on August 15, 1812, and en route the group was attacked by a Potawatomi and Winnebago ambush party. American relations with the Potawatomi and Winnebago tribes had been increasingly strained since William Henry Harrison's campaign against them in 1811, and many from these tribes sided with the British.

Few survived the attack, and settlers were not quick to return to Fort Dearborn; but in 1816 the Fort was rebuilt. Chicago remained a small settlement; in 1818 it was a village of less than 100. However, in 1833, with a steadily increasing population, it was incorporated into a village, and, in 1837, with over 4,000 inhabitants it became a city. (34 OP)

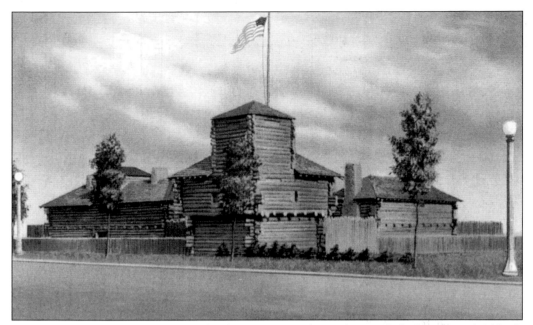

POSTCARD VIEW OF THE FORT. The description on this card states: "Blockhouse and soldier's barracks of the 'third Fort Dearborn,' reappear on the shores of Lake Michigan as part of the 1934 Century of Progress Exposition. Near here stood the original blockhouse and barracks of the old fort where inhabitants were victims in 1812 of the Dearborn Massacre—an eventful day in Chicago's Pioneer history." (CT)

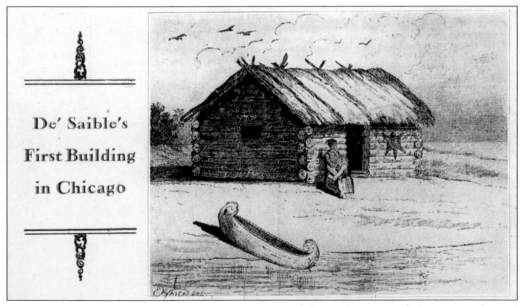

DE' SAIBLE'S FIRST BUILDING IN CHICAGO. Part of the Fair's Historical Group was the De' Saible home. Jean Baptiste Pointe du Sable (De' Saible) established the first permanent trading post on the Chicago River in 1779. Du Sable was born in Haiti to a French father and slave mother. In 1968, he was officially recognized by the State of Illinois as the "founder of Chicago."

REPLICA OF THE CABIN IN WHICH LINCOLN WAS BORN. The "Lincoln State" didn't miss this opportunity to showcase Abraham Lincoln's humble beginnings. The Lincoln backwoods cabin home was located in Hardin County, Kentucky, which later became Larue County. (RM)

AN AIRPLANE VIEW OF THE LINCOLN GROUP. Reproduced here were the Wigwam, the Inn at New Salem, Illinois, where Lincoln lived from 1831 to 1837 (Rutledge Tavern), the cabin in which Lincoln was born, the Indiana Cabin in Spencer County, and the grocery store in which Lincoln was a partner (the Lincoln-Berry Store in New Salem). (RM)

BYRD'S SOUTH POLE SHIP. Admiral Byrd purchased his ship, *The City of New York*, in 1927 for polar explorations. On August 25, 1928, the ship and crew headed to New Zealand, arrived on November 26th, geared up, and set sail for Antarctica. They first arrived in Antarctica on January 1, 1929, and set up their base camp, "Little America." Byrd and his crew continued their explorations until 1930 when the ship returned home and eventually became a museum of polar exploration. (MVB)

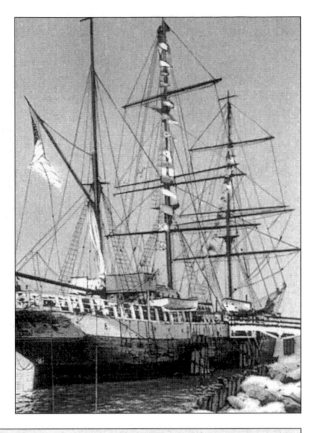

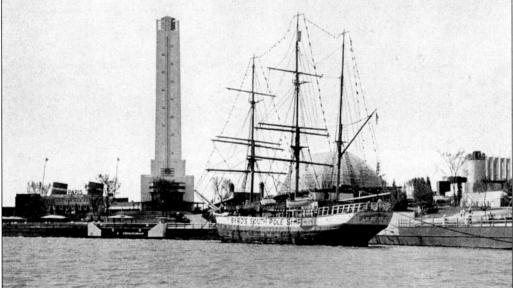

BYRD'S SHIP AND THE HAVOLINE THERMOMETER. Complete with a collection of relics used by seaman Admiral Byrd and his 82 men during his historic trip to the South Pole, Byrd's Ship was equipped with a reproduction of his Ross Ice Barrier base camp—"Little America" as well as some of the men who were part of the exploration, ready to tell visitors all about it. (34OP)

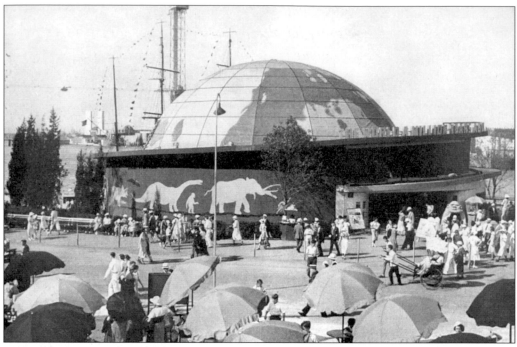

THE WORLD A MILLION YEARS AGO. "It is hard for us to conceive of a world inhabited by monsters other than those of industry. But when we cross the broad plaza at Twenty-Third Street to a spherical building on the hillside by the lagoon, we see examples of prehistoric creatures that would, in the flesh, terrify the bravest man." *–1933 Official Guide Book to the Fair.* (Photo—33OP.)

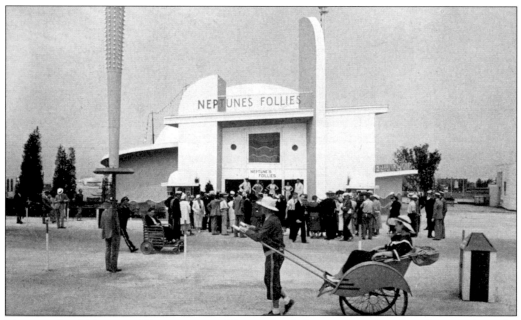

NEPTUNE'S FOLLIES. Here one could watch diving and swimming shows given by championship swimmers. (34OP)

Man is an animal with primary instincts of survival.
Consequently, his ingenuity has developed first and his soul afterwards.
Thus the progress of science is far ahead of man's ethical behavior.

Charlie Chaplin

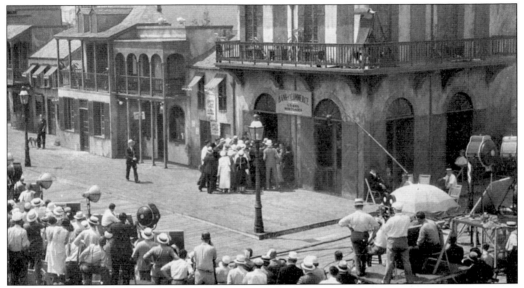

HOORAY FOR HOLLYWOOD. The makings of a Hollywood film were on hand at the Fair, complete with a full company of Hollywood actors, directors, electricians, and camera people. They exhibited how movies were made for the eager crowds. (33OP)

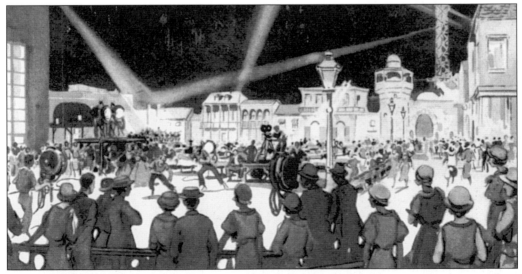

HOLLYWOOD AT NIGHT. Productions were filmed daily, and amateur movie photographers were invited to bring their cameras and film on the outdoor sets. Inside, one could watch audio recording and actual radio broadcasting through a glass overlooking the stage. Also on hand was a television exhibit heralded as "the art of tomorrow."(VB)

We are what we think. All that we are arises with our thoughts.
With our thoughts, we make the world.

Buddha

THE VILLAGES. (34OP)

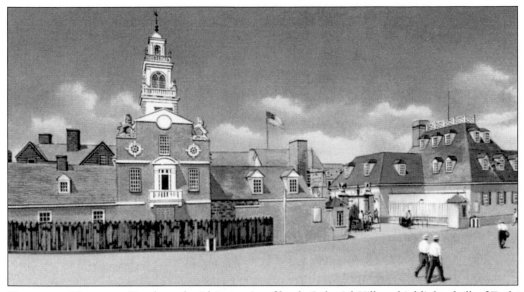

COLONIAL VILLAGE. Condensed within a strip of land, Colonial Village highlighted all of Early America. A historic reproduction of George Washington's Mount Vernon home stood at one end of the village and at the other, the Old North Church of Boston. On one side of the village one could see Paul Revere's house, the House of Seven Gables, the Old Boston State House, Betsy Ross's home, a Colonial Kitchen, Washington's birthplace, the Governor's Palace at Williamsburg, Virginia, and Longfellow's Wayside Inn. On the other side of the village, Benjamin Franklin's printing shop, the Village Smithy, the "Witch's house in old Salem," and the pirate's gaol, were visible. (CT)

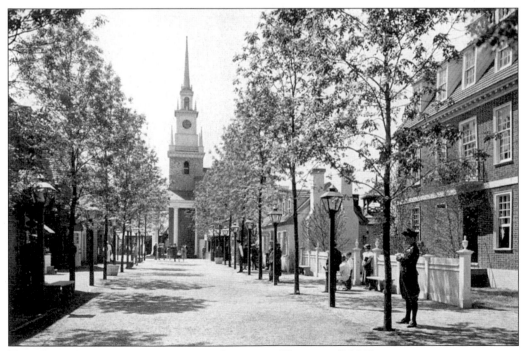

THE OLD NORTH CHURCH AT THE COLONIAL VILLAGE. (34OP)

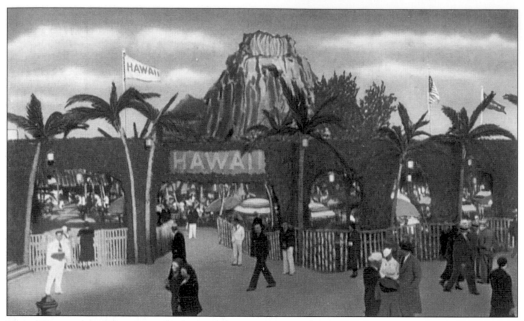

THE HAWAIIAN VILLAGE. "Palm Garden restaurant, featuring native music and dancing by Hawaiian entertainers. Background of the garden is a volcano. Sacrifice of an Hawaiian girl in its flaming crater is climax of the stage show."—*1934 Official Guide Book to the Fair*. (Image—AC.)

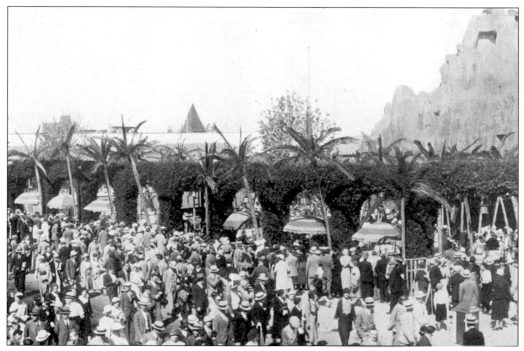

THE REVELERS AT THE HAWAIIAN VILLAGE. In the early 1930s, Hawaii was still an exotic and unfamiliar land. It would not become a state until March 18, 1959, 25 years after the Fair. (34OP)

THE MEXICAN VILLAGE. This village featured the Cathedral of Cuernavaca, native housing, music, dancing, traditional foods, an array of crafts, and modern products of Mexico. Within the Mexican Village one could bask in the "free and easy enjoyments of the land of sunshine south of the Rio Grande." (34GB)

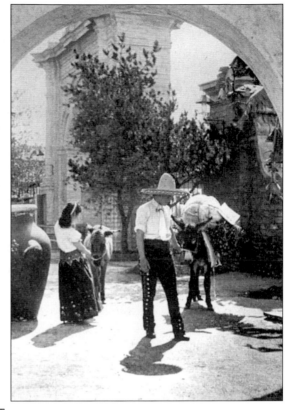

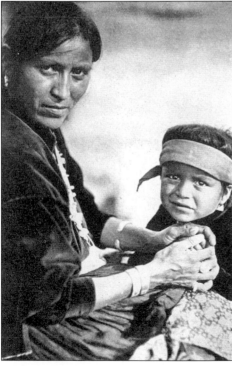

THE INDIAN VILLAGE. During the 1933 Fair, the Indian Village was located within the U.S. Army Camp, just north of the Thirty-First Street Entrance. Neither of these exhibits returned for the 1934 Fair. Advertised as living in "as close an approximation of their native life as it is possible to attain," the Indian Village sought to present a diversity of tribes. The description of this image from the *1933 Official Guide Book to the Fair*, however, states simply, "Types in the Indian Village." (33GB, photo by Mario Scacheri.)

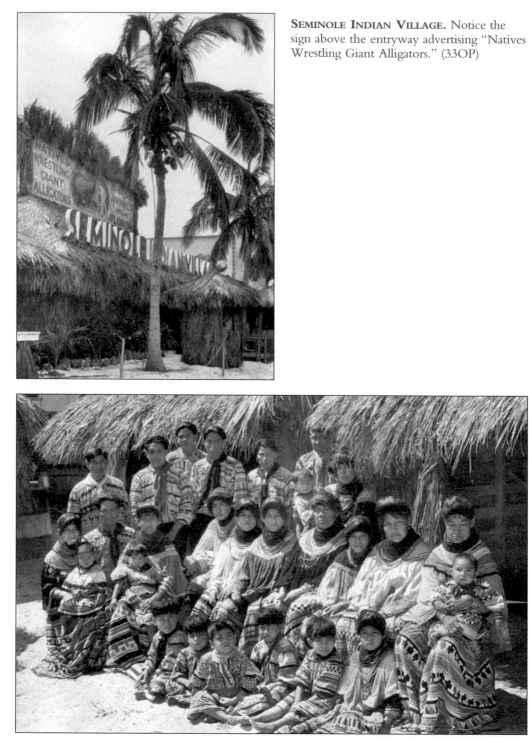

SEMINOLE INDIAN VILLAGE. Notice the sign above the entryway advertising "Natives Wrestling Giant Alligators." (33OP)

SEMINOLE INDIANS. Here, a group of Seminole Indians pose for the camera. The name Seminole comes from the Creek word for runaway, 'semino le,' and was first applied to the tribe in the late 1700s.(33 OP)

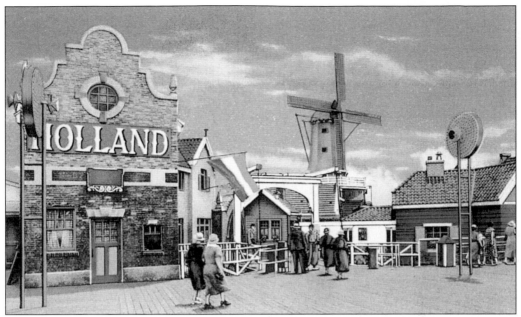

DUTCH VILLAGE. Windows, dikes, tulips, and canals filled the streets of the Dutch village. Maidens in traditional hats and wooden shoes and young men in breeches put on folk dances for visitors. (CT)

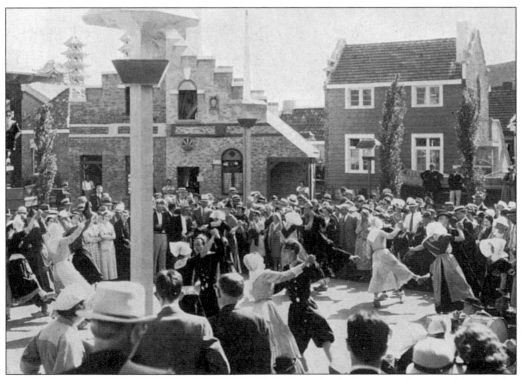

A FESTIVE STREET SCENE IN THE DUTCH VILLAGE. On-lookers watch as residents of the Dutch Village participate in a traditional folk dance. (34OP)

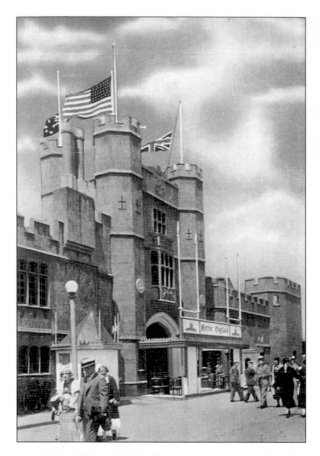

ENGLISH VILLAGE. Within the English Village one could find Shakespeare's Globe Theater and his house in Stratford-on-Avon, the original dwelling of John Harvard, founder of Harvard University, and the Old Curiosity Shop from Dickens's novel. In order to capture the true look and feel of old England, plaster casts were used to exactly replicate building exteriors. (CT)

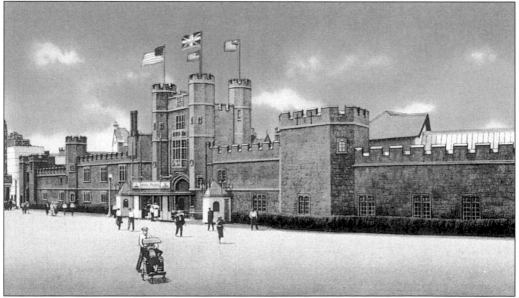

MERRIE ENGLAND. Designed to "truly exhibit English life," the English Village was one of the largest in the Fair. (AC)

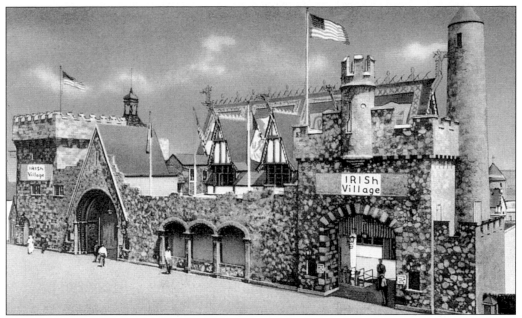

THE IRISH VILLAGE. The Irish Village consisted of buildings from 14 of the southern Irish counties as well as live entertainers, dancers, and musicians. (CT)

STREET SCENE IN THE IRISH VILLAGE. The buildings in the Irish Village ranged from the thatched cottage to Tara's Hall, a replica of the great meeting place of Irish Kings and bards. (33OP)

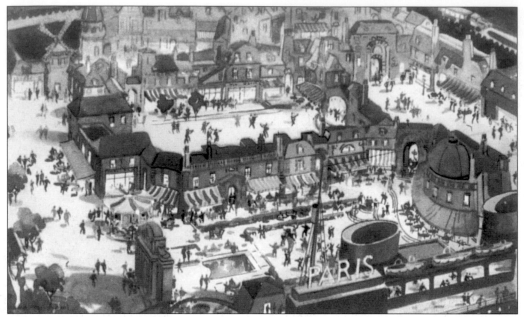

WATERCOLOR OF THE STREETS OF PARIS. Not far from the Twenty-Third Street Entrance, amid narrow Parisian streets, one could find sidewalk cafés, cigarette girls, strolling artists, fashion shows, peep shows, and wine cellars. Also nestled within the Parisian Village, the curious could find legendary fan dancer Sally Rand. Decorated in body paint, she performed with two large ostrich feathers to the titillation of many and disapproval of some. (VB)

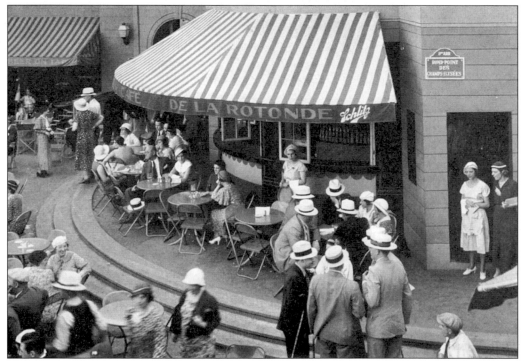

CAFÉ DE LA ROTUNDE IN STREETS OF PARIS.

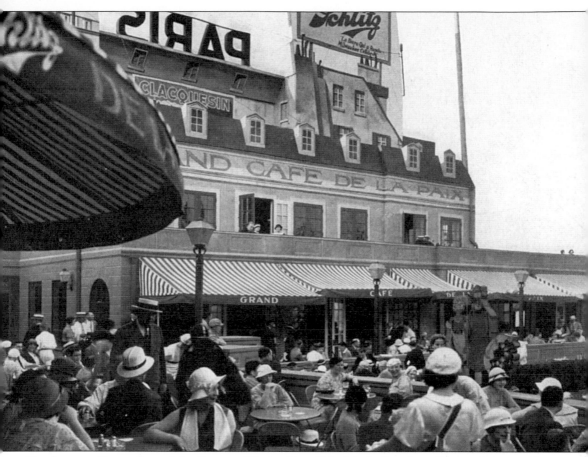

Café de la Paix. Part of the Streets of Paris, this café had indoor and outdoor seating as well as an orchestra and floor show where guests would dance. The cafés throughout the Streets of Paris were some of the most popular eateries, and great attention was paid to making sure that the experience was as authentic as possible. (34OP)

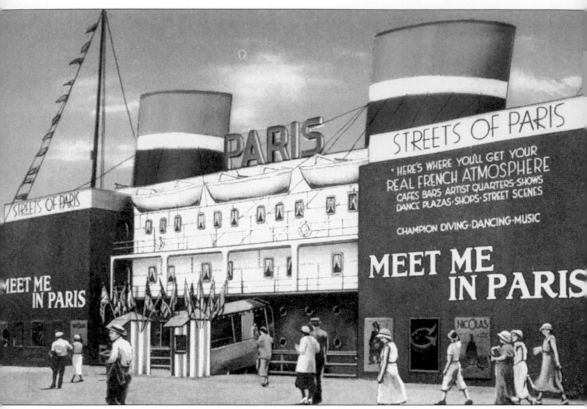

STREETS OF PARIS "SHIP." The side of this exhibit boasted, "this is where you'll get your Real French Atmosphere," and included cafés, bars, peep shows, shops, a dancing plaza, championship diving, artists' quarters, and street scenes.

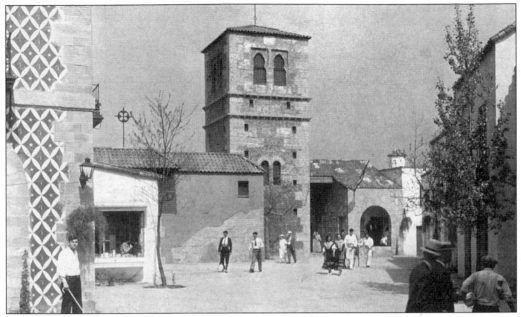

SPANISH VILLAGE. Recalling the "greatness of the empire that once dominated the world," the Spanish Village consisted of old gray castle walls and weather-worn houses. Within the shops throughout the village, one could find various Spanish arts and crafts. In describing the village, the *1934 Guide Book to the Fair* states: "The peculiar characteristics of the Spanish peoples, their dignity and courtesy which never desert them, either in rags or grandeur, are seen in this village which gives the visitor the special atmosphere of Spain." (34OP)

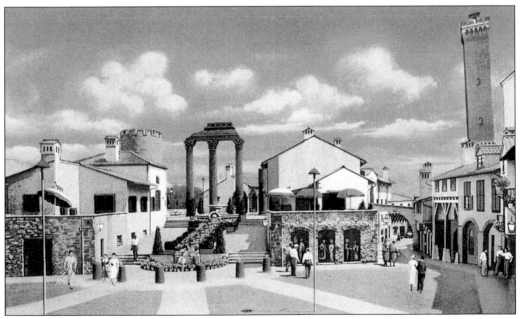

ITALIAN VILLAGE. "Here are shown various scenes that are natural to Italy. The Leaning Tower of Pisa in the background, the famous façade with the fountain, and all around, shops, restaurants, and theaters typical to Italy." (CT)

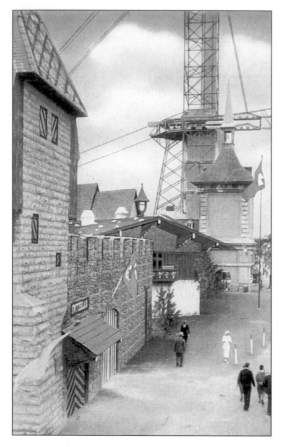

SWISS VILLAGE. Complete with an outdoor scene of rugged Alpine peaks and valleys, the Swiss Village was filled with native Swiss at work and play. Attractions within the village included St. Bernard dogs, Alpine guides, watch makers, cheese and lace makers, a wandering group of yodelers, and Swiss maidens. (AC)

SWISS VILLAGE AND "THE ALPS." The buildings in the Swiss village were designed after those in the capital city of Berne and were fashioned from actual plaster casts from Switzerland. (AC)

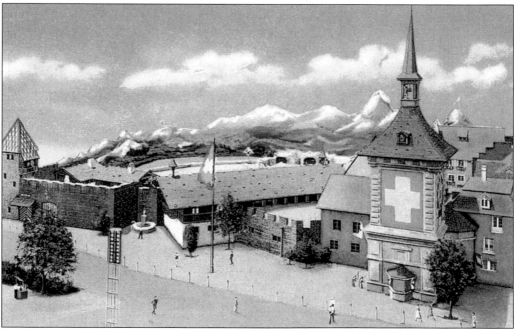

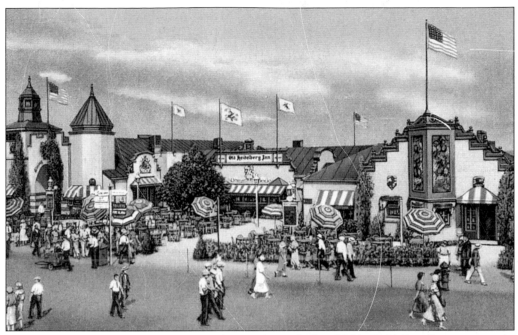

OLD HEIDELBERG RESTAURANT. This replica of the "Old Heidelberg" restaurant in Heidelberg, Germany, seated 3,500 people and was known for its German food and beer. (CT)

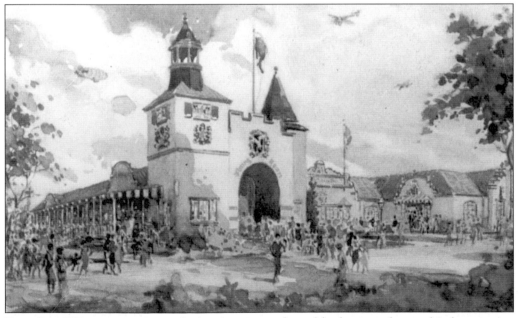

THE OLD HEIDELBERG INN. The large restaurant hosted both an outdoor and indoor seating area as well as a cafeteria lunch counter. In the early evenings, a symphony orchestra could be found playing and at night, a gypsy band. (VB)

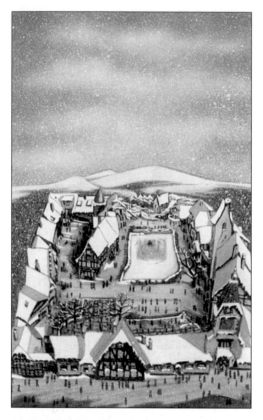

AERIAL VIEW OF THE BLACK FOREST VILLAGE. The village offered a glimpse into winter life in the black forest. Snow and ice was kept from melting, even in the hot Chicago summer, by an air conditioning plant.

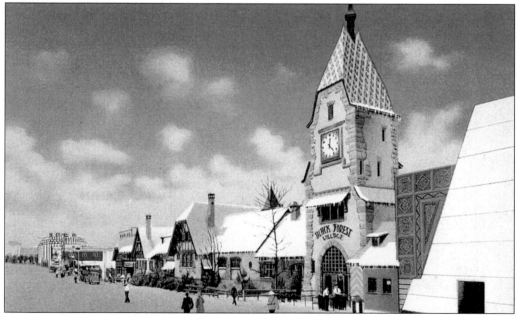

THE BLACK FOREST VILLAGE. The description of this postcard reads: "A bit of the rugged life of old Germany has been literally transplanted to make up the Black Forest Village at the World's Fair. Artificial snow enhances the typically German buildings, which are artificially cooled." (AC)

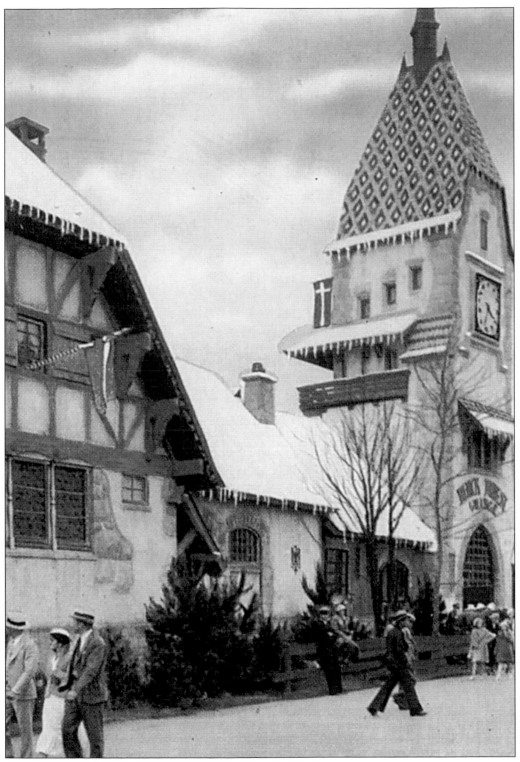

Detail of the Black Forest. (AC)

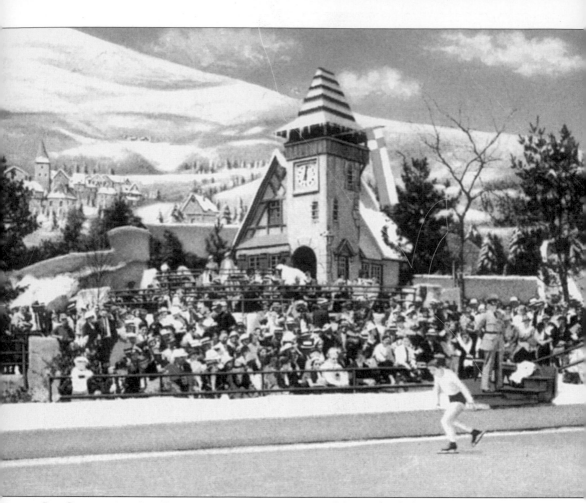

ICE SKATING IN THE BLACK FOREST. On account of the artificial climate created in the Black Forest Village, Fair-goers were invited to ice skate (or just watch) on the skating rink. (AC)

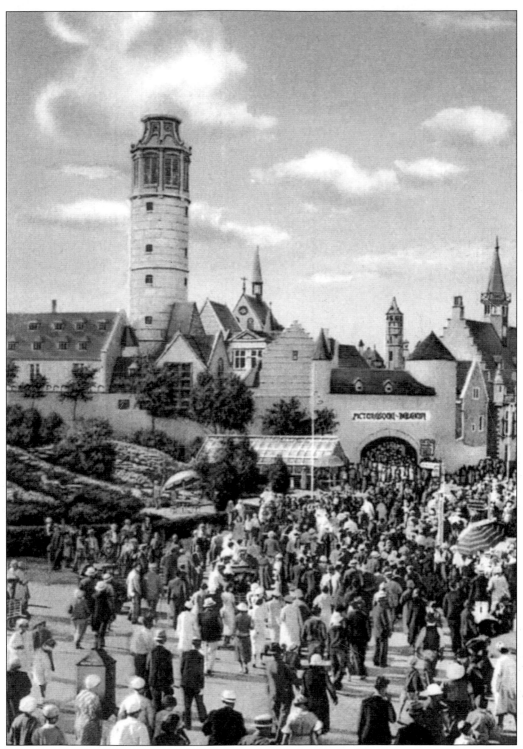

ENTRANCE TO THE BELGIAN VILLAGE. "This consists of 30 buildings, exact reproductions of buildings found in Brussels or Antwerp, the same stone and brick pavements; everywhere a strictly Belgian atmosphere prevails." (CT)

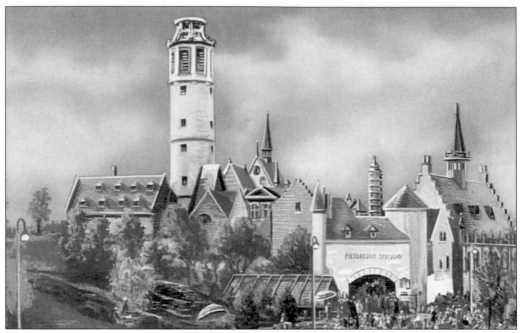

THE BELGIAN VILLAGE. Complete with faithful reproductions of the gate of Ostend, the old French-Gothic church of St. Nicholas at Antwerp, a city gate from medieval Bruges, and Belgian homes made from plaster casts of the real thing, the Belgian Village was a large and impressive exhibit. (CT)

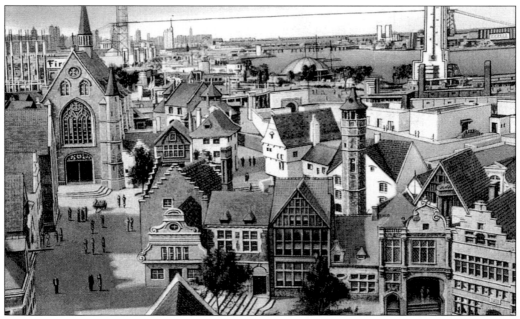

AERIAL VIEW OF THE BELGIAN VILLAGE. Throughout the shops and stores in the Belgian Village one could find handicrafts of all kinds. And on the cobbled streets, Belgian dogs could be spotted pulling milk carts. (AC)

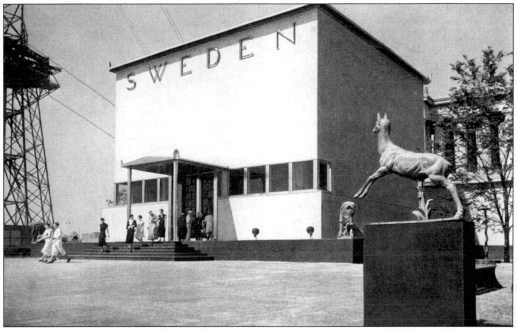

THE SWEDISH EXHIBIT. This building was constructed by the Swedish Government and contained exhibits in glassware, ceramics, silversmithing, pewter, furniture, and textiles. It also contained designs for reproduction made by prominent Swedish artists. (33 OP)

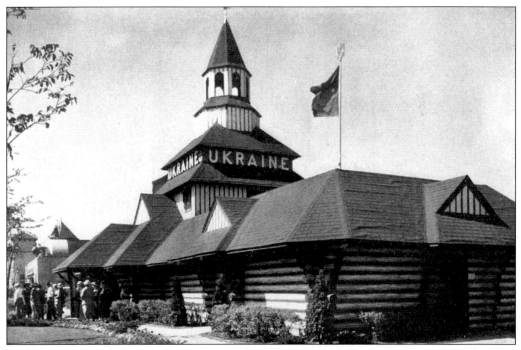

THE UKRAINIAN EXHIBIT. Located near the Thirty-Seventh Street Entrance, the Ukrainian Exhibit housed pottery, paintings, and embroidery from the region. Inside there was a theater where one could see live Ukrainian plays, dances, and singing. (33 OP)

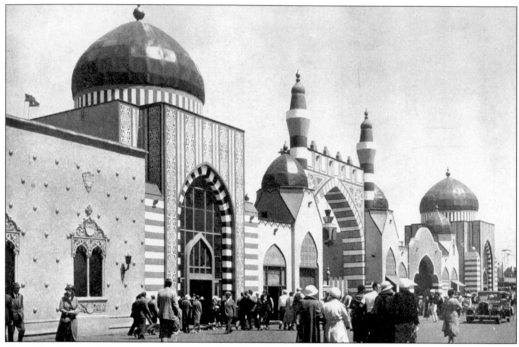

THE ORIENTAL VILLAGE. The magnificent architecture and strikingly colorful appearance of the Oriental Village made this exhibit truly stand out. Consisting of primarily Northern African and Middle Eastern participants, the name and description (from the *1933 Official Guide Book to the Fair*) is evidence of the ethno-centricism that still plagued 1930s America. "The streets are paraded by typical Moors in costume, who sell their barbaric wares in this wonderful reproduction of Northern Africa." (33 OP)

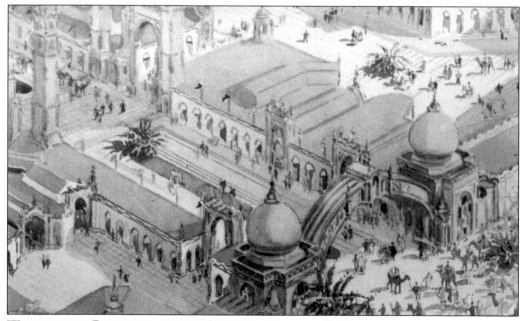

WATERCOLOR POSTCARD OF THE ORIENTAL VILLAGE. (VB)

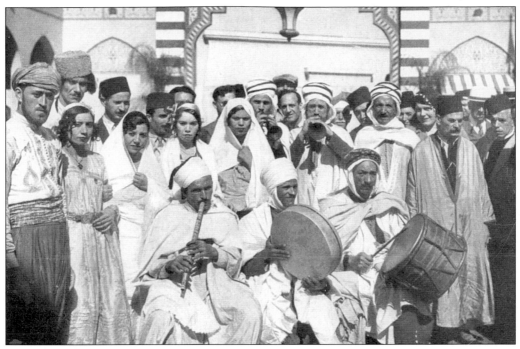

BAND OF PERFORMERS IN THE ORIENTAL VILLAGE. (33OP)

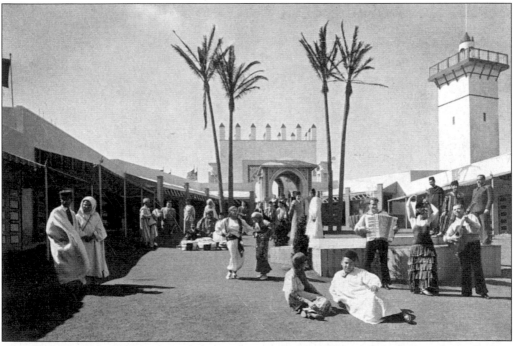

THE OASIS. This generic south-Mediterranean desert village was loaded with interesting entertainment. From Syrian war dances to "an Oriental dancer [displaying] her art and jeweled costumes" to wandering sword swallowers and mystics, the Oasis was a lively spot on the fairgrounds. (34GB)

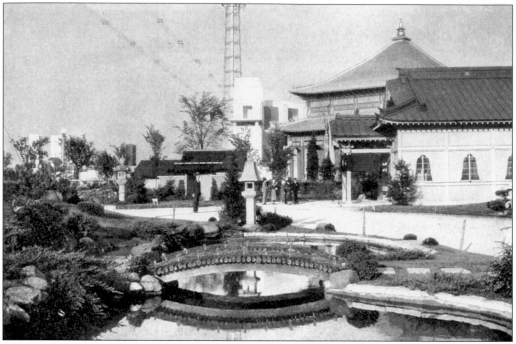

THE JAPANESE GARDENS. Housed within the Japanese exhibit, world-famous Japanese handicrafts including silk work, cloisonne, embroidery, and Japanese china could be found. On the more scientific end, the process of silk making was displayed from cocoon to the finished product. (33OP)

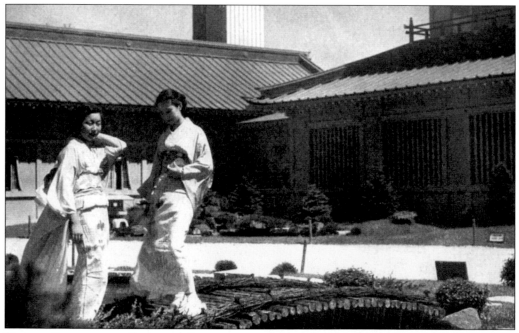

YOUNG GIRLS IN THE JAPANESE PAVILION. A Japanese Tea Garden was also part of the exhibit and tea ceremonies were performed by Geisha girls as Fair-goers watched. Ironically, less than 10 years later the U.S. would go to war with Japan. (33OP)

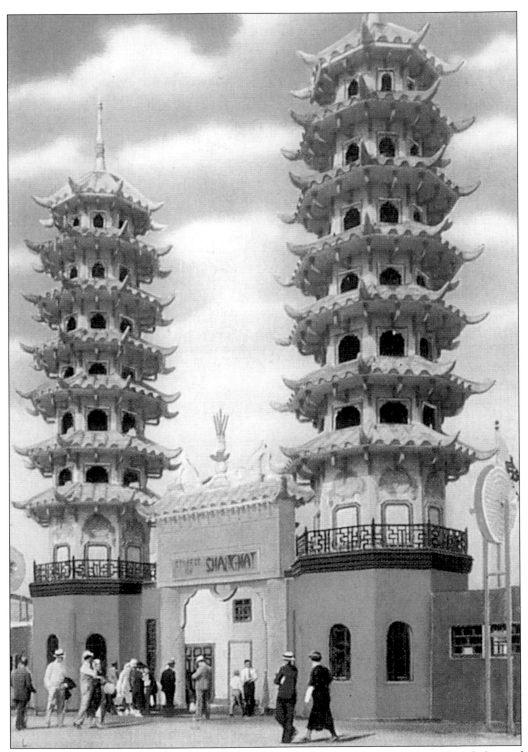

THE STREETS OF SHANGHAI, CHINA. "Where West meets East. A Nanking Road shop of Shanghai. Also showing the famous Imperial Chinese Gold Exhibit." (AC)

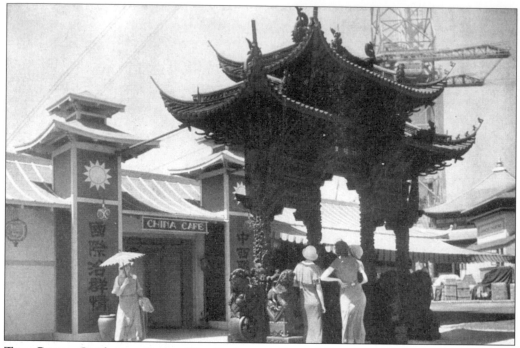

THE CHINA CAFÉ AND GATE. The Teakwood Gate of Honor was an elaborate and highly detailed ceremonial arch. At the restaurant just beyond the gate, one could find native dishes, dance music, and a floor show given by Chinese entertainers. (33OP)

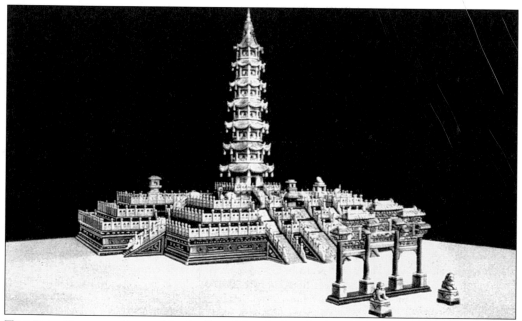

THE JADE PAGODA. Featured in the Republic of China building at the fair, the Jade Pagoda is a wonder of artistry. Crafted for 1,500,000 hours, it has long been heralded a treasure of China. (CT)

INTERIOR OF THE GOLDEN PAVILION OF JEHOL. "In the center background the Image of the great Avalokitecvara smiles serenely down upon the worshippers from its stone table. The patron saint of Tibet and protector of its capital is supposedly reincarnated in the Dalai Lama of Lhasa." The former Chinese province of Jehol was captured by the Japanese in early 1933. It was not restored to China until after WWII. (MVB)

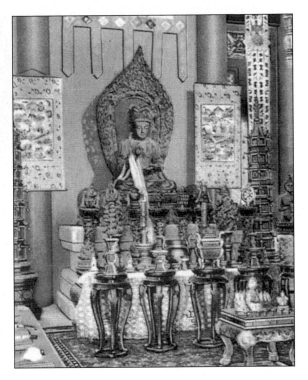

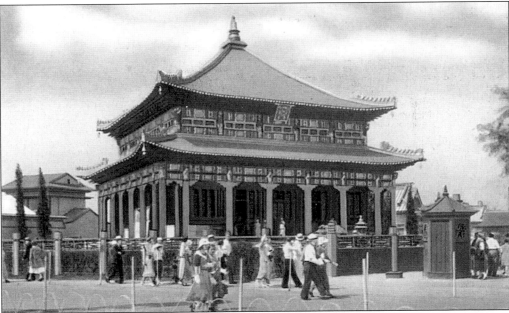

THE LAMA TEMPLE. Located east of the Hall of Science at Sixteenth Street, the World's Fair Lama Temple was an exact reproduction of the original built in 1767. The reproduction consisted of 28,000 pieces created and numbered in China and then shipped to Chicago to be assembled for the Fair. The description on the back of this card reads. "The Oriental splendors enjoyed by the old Manchu Emperors never approached the magnificence of the Lama Temple by night at the World's Fair." (CT)

THE EGYPTIAN PAVILION. A reproduction of the Temple of Philae, which dates from the Pharaonic period, 300 BC to 300 AD, the Egyptian Pavilion housed statues of ancient Egyptian kings and scientists. There was even a life size statue of King Tut. Visitors could also obtain information on traveling to Egypt in the future.

THE BEACH ON THE MIDWAY. On the Fair's midway thrill seekers, lovers, the curious, and even the scientist found complete and utter entertainment. The Beach Midway was host to an array of attractions including: the Auto Scooter, Carrousel, Cyclone Coaster, Giant Cone Slide, Ferris Wheel, Bug Ride, Catapult, Dutch Village, Flea Circus, Solomon's Temple, Motordome, Midway Beach Café, Night Club, Shooting Gallery, Swanee River Boys, Streets of Shanghai, The World Beneath, Trip Down the Lost River, Winston Racer, and Zoo. (34OP)

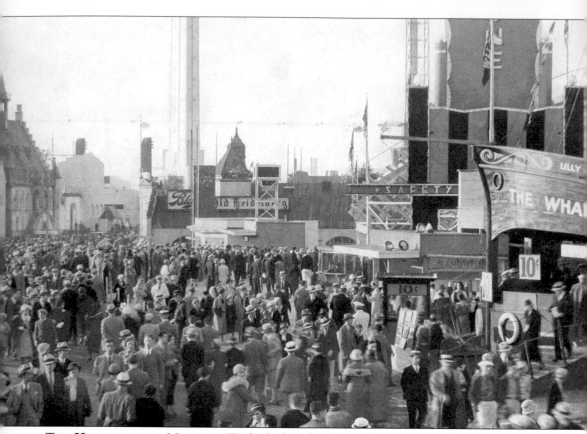

THE HEART OF THE MIDWAY. "Ride the breath-taking roller coaster, or the flying turns that combine the thrills of the toboggan with those of a coaster. Play the games. Watch the tricks of magic. Visit the place where daring youths dive into tanks and wrestle with alligators. Enter here where beauties of the Orient dance to strange tunes, and wrestlers, fencers, swordfighters, and Egyptian diviners and jugglers, give you glimpses of Cairo, Damascus, Tunis, Tripoli, and Algiers. See the 'apotheosis of America's womanly pulchritude,' the 'living wonders,' the Siamese Twins, giant people, and other 'freaks' gathered from the four corners of the earth."—*1933 Guide Book to the Fair.* (34OP)

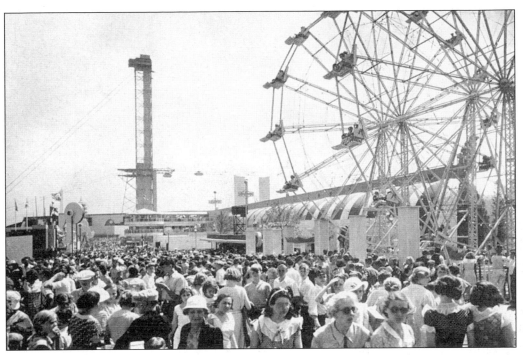

CROWDS ON THE MIDWAY.

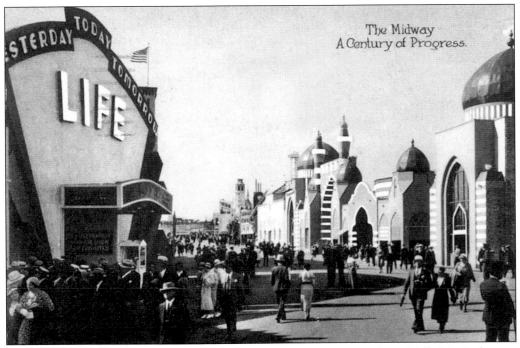

THE MIDWAY. The message on this postcard from Ruth and Len to their "Folks" in Dubuque, Iowa, dated August 1, 1933, states, "Just had quite a rain here. We were in the show. Didn't cool it off much tho. Be home some time to-morrow nite. Don't know what time. May be early—probably late."

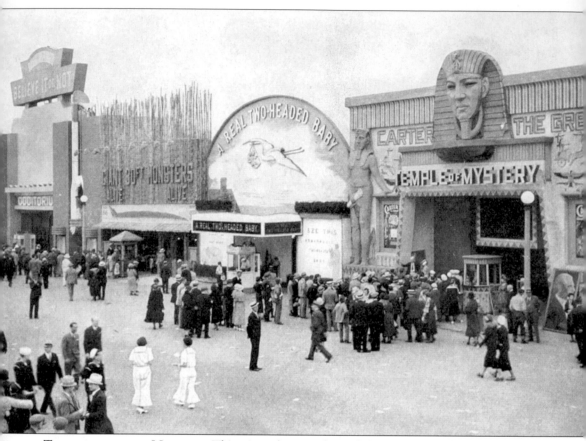

THRILLS ON THE MIDWAY. This view shows a few of the many interesting sights on the Midway: "Ripley's Believe It of Not?", A Real Two-Headed Baby, and the Temple of Mystery. Almost two million people visited Ripley's first "Odditorium" at the World's Fair. Inside, a wide array of exhibits, from the macabre to the curious, could be found.

FRANK BUCK'S JUNGLE CAMP ON THE MIDWAY BOARDWALK. "The Mountain of a thousand laughs. Several hundred Rhesus monkeys brought from India by 'Bring em Back Alive' Frank Buck, as seen in Frank Buck's Jungle Camp on the Midway Boardwalk at a Century of Progress, 1934." (AC)

INSIDE THE RED CROWN CAGE OF FURY. Sponsored by Standard Oil, this exhibit was held in an outdoor arena that seated 2,500 people. The show consisted of 33 jungle born lions and tigers performing as an ensemble under the careful watch of Alan King. The lions were from Barbary and Central Africa, and the tigers were from Sumatra and Northern China. (33OP)

121

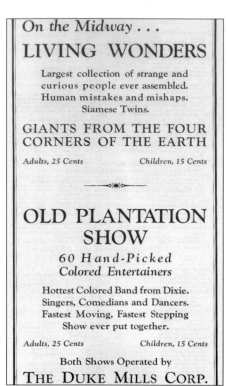

On the Midway . . .

LIVING WONDERS

Largest collection of strange and
curious people ever assembled.
Human mistakes and mishaps.
Siamese Twins.

GIANTS FROM THE FOUR CORNERS OF THE EARTH

Adults, 25 Cents Children, 15 Cents

OLD PLANTATION SHOW

60 Hand-Picked
Colored Entertainers

Hottest Colored Band from Dixie.
Singers, Comedians and Dancers.
Fastest Moving, Fastest Stepping
Show ever put together.

Adults, 25 Cents Children, 15 Cents

Both Shows Operated by

THE DUKE MILLS CORP.

ADVERTISEMENT FOR THE "OLD PLANTATION SHOW." For 25 cents adults could gain access to the Midway's Old Plantation Show, and for 15 cents they could take their children. Exemplifying the times within which the Fair was set, the show was popular and well-attended. Incidentally, the show was one of the few employers of African Americans at the Fair. (33GB)

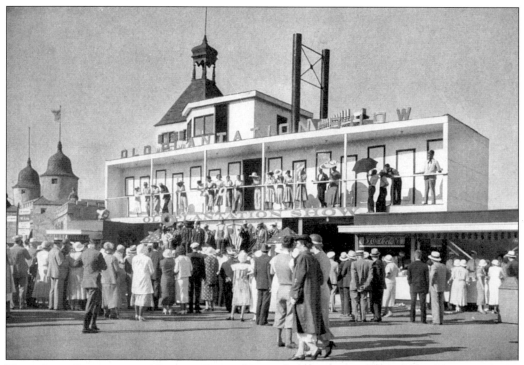

THE OLD PLANTATION SHOW. From this angle we can see crowds gathering and the performers on the upstairs level. Directly to the left of the stage stood the Midget Village.

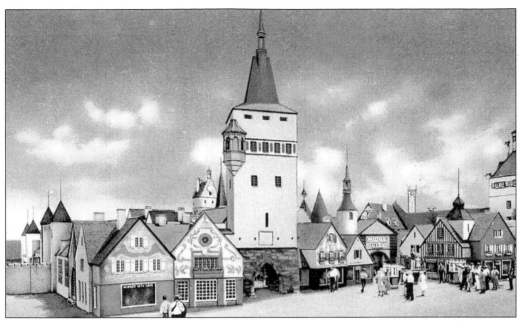

MIDGET CITY. "One of the most interesting spots on the Fair Grounds. Here many people of the Lilliputian variety live in their tiny houses and conduct activities necessary to running a city." (CT)

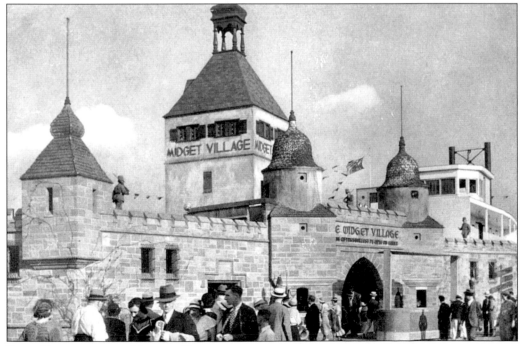

FAIR-GOERS AT THE MIDGET VILLAGE.

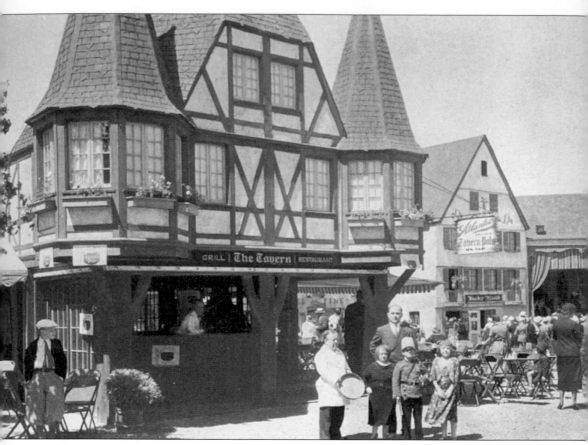

LILLIPUTIANS IN MIDGET CITY. A reproduction of the ancient city of Dinkelspuhl, Bavaria, reduced to midget scale, Midget City consisted of 45 buildings including a municipal building, police station, fire department, church, school, shops, filling station, and newspaper. The shops advertised "Midget Handicrafts," and one could take a somewhat cramped ride in the miniature taxicab. The city's mayor, Mayor Doyle, was 33 inches tall. Incidentally, the Midget Village Restaurant served full-size meals. (33OP)

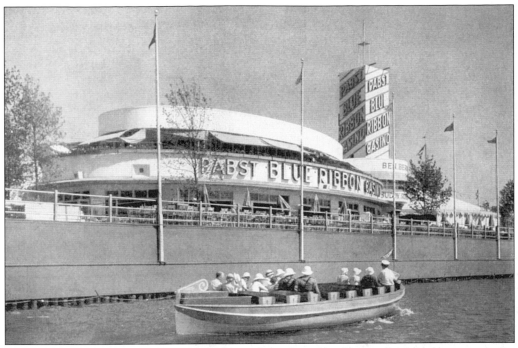

PABST BLUE RIBBON RESTAURANT. After a long day of exploring all of the many treats the Fair had to offer, visitors could stop into the Pabst Blue Ribbon Restaurant and enjoy an icy cold beer and a sandwich for less than a quarter. (34OP)

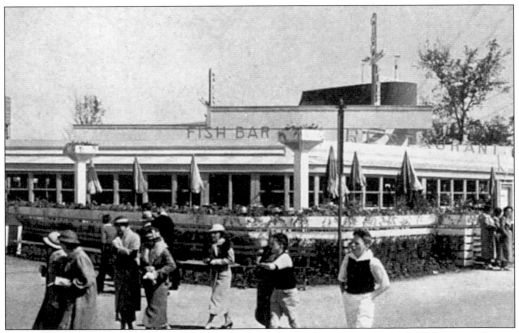

THE MILLER HIGH LIFE FISH BAR. The end of Prohibition in April of 1933 was welcome news to many, particularly those in the business. At the Miller High Life Fish Bar, seafood and beer were the house specialties. (34OP)

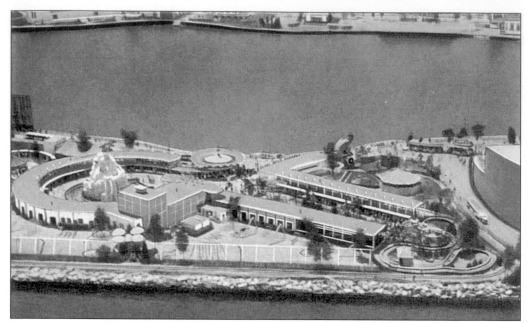

AERIAL VIEW OF THE ENCHANTED ISLAND. One of the most parent-friendly features of the Fair was the Enchanted Island. Here parents could drop their children off and then head on to enjoy the Fair without the little ones in tow. The message on the reverse of this card states it is the place "Where the child can be checked all day and one knows they will be well cared for." (AC)

AMUSEMENTS AT THE ENCHANTED VILLAGE.

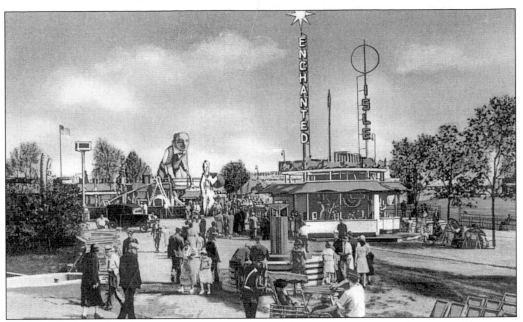

THE ENCHANTED ISLAND. Although parents had to pay an admission charge for their child to enjoy the Enchanted Island, it afforded them the luxury and economic freedom of visiting other paid exhibits without the need of an additional ticket. Part of the popularity of the Enchanted Island may have been due to the Great Depression. According to this postcard, "Here are old time and new amusement devices for children. Here young people can spend hours of real pleasure while their folks visit the many exhibits of the Fair." (CT)

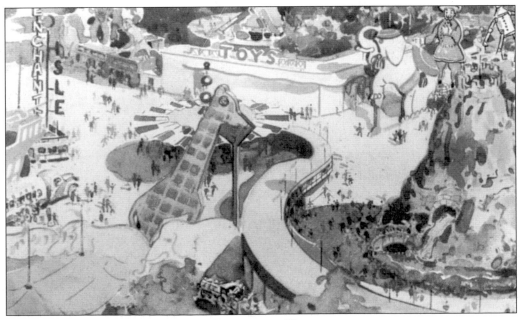

ARTIST'S INTERPRETATION OF THE ENCHANTED VILLAGE

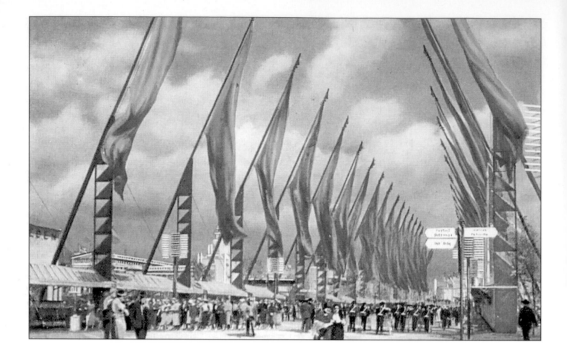

Bibliography

A Century of Progress International Exposition. (1934). *Official Guide Book World's Fair 1934*. Chicago: Author.

A Century of Progress Administration Building. (1933). *Official Guide Book of the Fair*. Chicago: Author.

Beck, Emily Morrison. (1980). *Familiar Quotations, John Bartlett*. Boston: Little Brown and Company.

Blum, John; McFeely, William; Morgan, Edmund; Schlesinger Jr., Arthur; Stampp, Kenneth; Woodward, C. Vann; (Eds.). (1993). *The National Experience*. New York: Harcourt Brace Jovanovich.

Kaufmann and Fabry Company. (1934). *Official Pictures of the 1934 World's Fair*. Chicago: A Century of Progress.

———. (1933). *Official Pictures of A Century of Progress Exposition*. Chicago: The Reuben H. Donnelly Corporation.

Rand McNally. (1933). *Chicago's Century of Progress*. Chicago: Author.

ADDITIONAL READING:

The Chicago Historical Society offers a wonderful online tour through the Fair on there website: www.chicagohs.org. The Chicago Public Library website is also very informative and can offer answers to almost any Chicago related question: www.chipublib.org. For additional information on happenings in the 1930s, you might take a look at the History Channel site.